PICTURING
ALGERIA

A COLUMBIA|SSRC BOOK

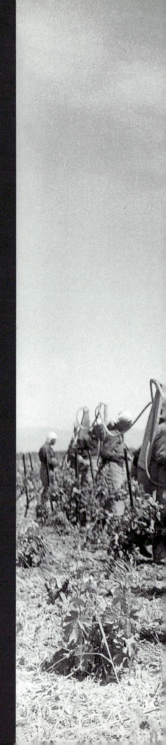

COLUMBIA UNIVERSITY PRESS | NEW YORK

A **COLUMBIA | SSRC** BOOK

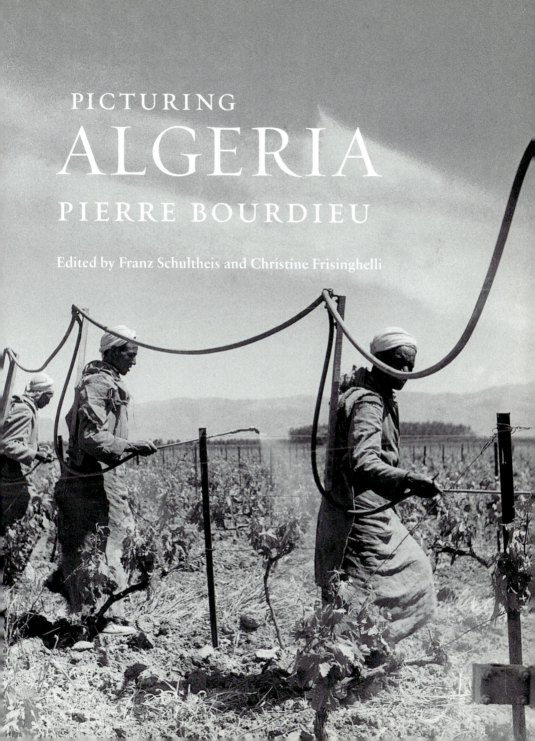

PICTURING
ALGERIA
PIERRE BOURDIEU

Edited by Franz Schultheis and Christine Frisinghelli

Columbia University Press
Publishers Since 1893
New York Chichester, West Sussex
cup.columbia.edu
© 2003 Camera Austria/ Fondation Pierre Bourdieu
Translation copyright © 2012 Columbia University Press
All rights reserved

First published in French as *Images d'Algérie* by Camera
Austria/Actes Sud. The English language edition of this
compilation and the essays by F. Schultheis and
C. Frisinghelli, and the interview with Bourdieu by
F. Schultheis, are published with the kind permission of
Camera Austria and Fondation Pierre Bourdieu.

Excerpts from:

Travails et travailleurs en Algérie by Pierre Bourdieu. ©
 1963 Éditions Mouton & Co./De Gruyter. English
 excerpts (pp. 207, 352, 353, 461, 464, 473, 502, 503, and
 511) translated from French by John Doherty.
Masculine Domination by Pierre Bourdieu, translated by
 Richard Nice. © 1998 Éditions de Seuil. First published
 in French as *La Domination masculine* by Éditions du
 Seuil. This translation © 2001 Polity Press. First pub-
 lisher of English edition: Polity Press in association with
 Blackwell Publishers Ltd. First published in the U.S.A.
 by Stanford University Press, 2001. All rights reserved.
 Used with the permission of Stanford University Press,
 www.sup.org
The Logic of Practice by Pierre Bourdieu, translated by
 Richard Nice. © 1980 Éditions de Minuit. First published
 in French as *Le Sens pratique* by Éditions de Minuit. This
 translation © 1990 Polity Press. First publisher of English
 edition: Polity Press in association with Blackwell
 Publishers Ltd. First published in the U.S.A. by Stanford
 University Press, 1990. All rights reserved. Used with the
 permission of Stanford University Press, www.sup.org
Algeria 1960 by Pierre Bourdieu. © 1977 Éditions de
 Minuit. First published in French as *Algérie 60* by Édi-
 tions de Minuit. This translation © 1979 Cambridge
 University Press. First publisher of English edition:
 Cambridge University Press.
The Social Structures of the Economy by Pierre Bour-dieu,
 translated by Chris Turner. © 2000 Éditions de Seuil. First
 published in French as *Les Structures sociales de l'économie*
 by Éditions du Seuil. This translation © 2005 Polity Press.
 First publisher of English edition: Polity Press.

Le Déracinement by Pierre Bourdieu. © 1964 Éditions de
 Minuit. English excerpts translated from French by John
 Doherty.
"Guerre et mutation sociale en Algérie" by Pierre Bour-
 dieu. © 2008 Éditions du Seuil. First published in French
 as *Esquisses algériennes* by Éditions du Seuil. English
 excerpts translated from French by John Doherty. Forth-
 coming English translation of *Esquisses algériennes* to
 be published by Polity Press.
"Paysans déracinés, bouleversements morphologiques et
 changements culturels en Algérie" by Pierre Bourdieu
 and Abdelmalck Sayad. © P. Bourdieu/A. Sayad, 1964. ©
 Études Rurales 12, January–March 1964. Paris. Éditions
 de l'EHESS. English excerpts translated from French by
 John Doherty.

Library of Congress Cataloging-in-Publication Data
Bourdieu, Pierre, 1930–2002.
 [Images d'Algérie. English]
 Picturing Algeria / Pierre Bourdieu ; edited by Franz
Schultheis and Christine Frisinghelli.
 p. cm.
 "First published in French as Images d'Algérie by
Camera Austria/Actes Sud." Catalog of an exhibition
held Jan. 23–Mar. 2, 2003, Institut du monde arabe.
Includes bibliographical references.
 ISBN 978-0-231-14842-9 (cloth : alk. paper)
 1. Bourdieu, Pierre, 1930–2002. 2. Algeria—Social
life and customs—20th century—Pictorial works.
I. Schultheis, Franz, 1953– II. Frisinghelli, Christine.
III. Title.
DT282.B68513 2012
965'.04—dc23
 2011043213

Columbia University Press books are printed on permanent
 and durable acid-free paper.
This book is printed on paper with recycled content.
Printed in the United States of America

c 10 9 8 7 6 5 4 3 2 1

Designed by Lisa Hamm

References to Internet Web sites (URLs) were accurate at
the time of writing. Neither the author nor Columbia Uni-
versity Press is responsible for URLs that may have expired
or changed since the manuscript was prepared.

CONTENTS

FOREWORD

CRAIG CALHOUN

Pierre Bourdieu is famous today as one of the most influential social scientists of the twentieth century. His writings inform analyses in sociology, anthropology, history, literature, and a range of other fields. And his influence extended to politics. His books on the reproduction of inequality in education informed 1960s protests. Decades later, his attacks on neoliberal globalization were among the most resonant. But in this book we are introduced to Pierre Bourdieu at the beginning of his career, and through photographs more than words. The photographs come from Bourdieu's years in Algeria during what became in the end the successful struggle for independence from French colonial rule. They are accompanied by passages from his texts about Algeria, but the images command the book.

These images are valuable in themselves. They take us to a time of great social drama amid wrenching social change. Many are memorable simply as photographs. But they are also valuable as a source of insight into the formation of Bourdieu's very distinctive and powerful intellectual perspective. They are not simply part of a youthful project, somehow prior to Bourdieu's sociology and anthropology. Taking these photographs was an intrinsic part of Bourdieu's research into Algerian society in the late 1950s and early 1960s. They and the fieldwork come to an end when he had to leave the country literally under cover of night after threats of violence from far-right-wing colonists. The photographs bridge the two sides of Bourdieu's account of Algeria: his partially reconstructive exploration of how traditional Kabyle society worked and his very-present-tense examination of the uprooting of peasants by forced resettlement and urban labor markets. But though the images shed

light on the ethnography, it is important that they are not contained by it. They are not mere illustrations but occasions for further thought.

* * *

In October 1955, the twenty-five-year-old Pierre Bourdieu arrived in Algeria to complete his national service.[1] A graduate of the prestigious Ecole Normale Supérieure, he had refused the easy path followed by most peers when drafted—entering the Reserve Officers' College. Still, his initial assignment was to a relatively privileged post with the Army Psychological Services in Versailles. He was deployed to Algeria only after he made clear his opposition to the French struggle to hold on to the colony—engaging in heated arguments, even with those who outranked him (a fact no one who knew Bourdieu will be surprised to discover). Being sent to the actual war was a punishment.

Bourdieu sailed to Algeria in the company of working-class and peasant soldiers with whom he identified as the son of a provincial postman. He tried, not entirely successfully, to persuade them of the problems with French occupation. As he realized, their very recognition that he had voluntarily (but perhaps only temporarily) renounced some of the privilege conferred by elite education only accented the class division between them. Assigned to national service as a clerk in the bureaucracy of the French army, he found himself working for a colonial administration he would come increasingly to hate as it repressed a growing insurrection. But Bourdieu's hatred was not only for the violence of the French military, but for the larger colonial project and the ways it disrupted and damaged the lives of individuals and the collective life of communities. He entered a country torn apart not just by colonialism but also by the introduction of capitalist markets and consequent social transformation. It was in this context that Bourdieu developed the concept of "symbolic violence" to refer to the many ways in which people's dignity and capacity to organize their own lives were wounded—from the forced unveiling of women to the disruptions a new cash economy brought

to long-term relations of honor and debt to the categorization of the rural as backward and the denigration of Berber languages (by Arabophones as well as Francophones).

Bourdieu was initially posted to boring duty with an army air unit in the Chlef Valley, 150 kilometers west of Algiers. Before long, however, he was reassigned to Algiers. The move was a favor from a senior officer who was also from Béarn, the same rural province as Bourdieu. Bourdieu's mother had interceded on his behalf.

Mothers don't get enough credit in histories of social science, and Bourdieu's made a second crucial contribution to his career, even more basic to this book. She bought him a Leica camera. This came a little later, though, as Bourdieu's engagement with Algeria grew deeper and became a crucial, formative influence on his career and life.

The photographs in this collection date from 1957 to 1960. By the time most were taken, Bourdieu had completed national service, written a book, and voluntarily returned to Algeria as a university lecturer. They are neither the completely naïve snapshots of a newcomer nor products of a fully formed sociologist or anthropologist. Bourdieu did not deploy his camera artlessly, simply to record, as in a few years he would describe French peasants doing in his book on photography. His camera was a Leica, not a Kodak Brownie, and his ambitions were greater. And the young Bourdieu was a good photographer; his pictures offer interesting, sometimes beautiful compositions. But when Bourdieu looked back on these photographs nearly a lifetime later, he said that the ones that moved him most were the most naive. The young man was ambitious but the older man recognized that the camera served him better when it recorded a scene that made him think more deeply on reexamination than when it illustrated what he already thought was going on.

Bourdieu was in the process of teaching himself how to be a social scientist and especially a fieldworker. He tried out a range of techniques: surveys, observations, in-depth interviews, sketches of village geography and houses, and even Rorschach tests. Photography was one crucial way in which Bourdieu gathered data—and developed his sociological eye.

Some of the photographs document research sites and served as mnemonic devices to spark his memory later. Some, rather more artfully, try to make a point. By his own account, Bourdieu was drawn especially to photograph scenes that brought to the foreground transitions and dislocations, the contrast between old and new; "situations that spoke to me because they expressed dissonance," as he told Franz Schultheis.[2] There are striking and sometimes quite wonderful examples here. More than a few focus on veiled women—riding a scooter, buying a newspaper, in front of a shop selling radios. Others show peasant men in the city, often with a tiny capital of objects for sale and looking uncomfortable.

A shy, or perhaps better, a private man for all his later public prominence, Bourdieu was conscious of the voyeurism of photography. He did not shrink from photographing much that seemed more private than public—even a girl's circumcision. But many of his photographs are shot from an oblique angle or show their subjects from the back. As Kravagna notes, the subjects of Bourdieu's photographs seem often to be in retreat; they seldom look back at the camera.[3] Indeed, Bourdieu eventually replaced the Leica his mother had given him with a Rolleiflex because of the advantage a through-the-top viewfinder offered to a photographer who wanted to be unobtrusive. Beyond personal diffidence (and he was self-confident at the same time as shy), Bourdieu was conscious that he was manifestly a Frenchman photographing Algerians.

Neither Bourdieu's photography nor his fieldwork was without background and agenda. He came to Algeria at odds with colonialism, yet indirectly informed by it. If justification for colonial rule came in the idea of a *mission civilisatrice*, and more basically the notion that "the natives" simply lacked civilization, much early anthropology was devoted to demonstrating that the societies into which colonialism intervened were in fact civilized, had culture, had an organized way of life. So too the early work of Bourdieu. Indeed, Bourdieu reports that at first he shied away from reporting on ritual practices because these would be taken as evidence of the primitivism of the Kabyle.[4] Conversely, if the basic fact of colonialism was domination, then the ethical imperative for the researcher was to make domination manifest.

Steeped in Bachelard's epistemology and history of science, Bourdieu embraced the notion that knowledge was created in a series of corrective moves. The effort to understand Algeria and Algerians was part of the necessary correction for colonialism itself. But there was the danger of overcorrection. The natives could be represented as inhabiting a more completely functional and internally closed culture and society than was ever historically real. And colonialism could be represented as so completely domination that its seductions and the motivations for collaboration were hidden.[5] Or taking the Bachelardian opposite perspective could lead the anthropologist to leave colonialism itself out of the picture in seeking to portray autonomous native society: The French seldom appear as such in Bourdieu's account of colonial Algeria and very little in these pictures (though note the tank seen through the back window of Bourdieu's car; see p. 49).

* * *

Bourdieu had spent 1956 and 1957 reading through all the literature on Algeria he could find. His new assignment in Algiers placed him in the documentation and information service of the General Government. This provided him with access to a good library. He made intensive use of it, and began to build a range of contacts with Algerian intellectuals and French Algerians sympathetic to the Algerians.[6]

As Bourdieu read, he developed the plan of writing a synthetic account of the colony. This was an unsurprising, if ambitious, move for a brilliant young ENS graduate contemplating an academic career. It was also a political move, as Bourdieu intended the book to inform debates over Algerian independence and specifically to provide a deeper picture of the country to Left intellectuals—not least Jean-Paul Sartre—whom Bourdieu thought advocated a cause without really understanding its social circumstances.

Sociologie de l'Algérie appeared in 1958, based overwhelmingly on the existing literature of ethnographers, missionaries, and officials (often read against the grain of authors' original interpretations), informed a little by

Bourdieu's own interviews and contacts, and perhaps more by simply the experience of living in Algeria.[7] It focuses mainly on Algeria's three main "traditional" Berber societies, more briefly on the Arabophone population (urbanites, nomads, and the recently or partially settled), and then on the factors that knit the groups together very imperfectly: Islam, markets, and colonialism. It closes with an account of alienation, deculturation, and the emergence of a class society. The book's theoretical argument was not greatly developed but presaged Bourdieu's later work in many ways. In a sense, the book's analytic framework was a Durkheimian account of social solidarity counterposed to an examination of the effects of colonial domination. Above all, without using the word *habitus*, Bourdieu began to develop an account of the ways Algeria's different traditional societies gave their members an implicit sense of how to live—"real psychological dispositions" based on "cultural apprenticeship"—and how the colonialism both undermined the political economy of traditional societies and created new circumstances to which traditional dispositions were inadequate. The book found a readership and had some impact, not least among the Left intelligentsia Bourdieu had set out to inform. He was invited to write for *Esprit* and *Les Temps modernes*.

Sociologie d'Algérie might have remained simply the work of a precocious (and angry) young man had Bourdieu stayed in France and written his contemplated doctoral thesis on the phenomenology of Maurice Merleau-Ponty. But Bourdieu did not let his first book mark the end of a troubling Algerian phase; he made it the beginning of a commitment to the country, especially to the Kabyle peasants and migrants with whom he identified, as well as to social science. Taking up a new métier involved shifting not just his theoretical readings but also his own habitus. Bourdieu began to teach himself to be a fieldworker, an analyst of empirical data, a theorist not simply of universal truths but of concrete conjunctures and contradictions. Here the camera played an important role.

Bourdieu returned to Algeria in 1958, taking up an appointment as a lecturer at the University of Algiers. Despite his training and position as a philosopher, Bourdieu found his way out of the library and off campus. This

helped shape his lifelong project of doing philosophical work by concrete sociological investigation rather than just abstract reflection. He traveled around the country when he could and simply walked the streets in Algiers. He got to know dissidents among the French in Algeria, including not least members of the White Fathers and other religious orders. Importantly, he developed relationships with some of his Algerian students, especially the few who came from Kabyle peasant backgrounds, *miraculés* like himself.[8] Most prominent among these, Abdelmalek Sayad became Bourdieu's assistant and collaborator, a friend until his death three years before Bourdieu's own, and in his own right a major analyst of migrants and migration. Indeed, Sayad accompanied Bourdieu not just on his Algerian research trips but also on an extended stay in Bourdieu's native village in the Béarn. They worked together writing up their Algerian studies—notably for the book *Les Déracinés*—but this sojourn also became a kind of sociological experiment, as Bourdieu looked at the effects of administrative and market centralization in his native village in relationship to what he had seen in Algeria.[9]

Despite his lack of prior fieldwork experience, Bourdieu was taken on as part of a large research effort organized by the Association for Demographic, Economic, and Social Research (ARDES, the Algerian branch of the French National Institute for Statistics and Economic Studies, INSEE). As he would do more than once in his career, Bourdieu redefined the projects—and gathered collaborators. The result was two remarkable books. One, *Travail et travailleurs* (with Alain Darbel, Jean-Paul Rivet, and Claude Seibel) examined the lives of labor migrants, workers in the new metropolitan economy of colonial Algeria. The other, *Les Déracinés*, co-authored with Sayad, portrayed the crisis of traditional agriculture and the resettlement camps created by a brutal policy of forcibly uprooting peasants in order to try to squelch resistance to the colonial war. The photographs published here date mostly from the same time as this research.

The two books are remarkable in themselves, and an important counterpoint to the more familiar "anthropological" studies in Bourdieu's famous *Outline of a Theory of Practice*. In French, Bourdieu's corpus of Algerian

studies presents perhaps too sharp a gulf between accounts of traditional society and the deculturation of resettlement camps and labor migration. But what is available in English is even more misleading, for Bourdieu's studies of traditional Kabyle society stand alone. Neither *Travail et travailleurs* nor *Les Déracinés* has been translated.[10] The result is that Bourdieu's reconstruction of traditional Kabyle society is not complemented by his analyses of the domination that befell it. Bourdieu's brilliant, structuralist evocation of the Kabyle house should be read alongside his devastating account of the imposition of order without reference to traditional culture—houses precisely bereft of what would make them Kabyle houses—in the resettlement camps.[11] Of course it usually isn't read this way in French, and the author of both studies allowed them very separate existences. But an Anglophone reader literally cannot put the two together. Moreover, the account of how traditional society worked is incorporated into Bourdieu's main theoretical texts, *Outline of a Theory of Practice* and *The Logic of Practice*. The account of dispossession from it is not.

The same sort of gulf marks the relationship between Bourdieu's classic study of cultural hierarchy in France, *Distinction*, and the massive book and surprise bestseller *La Misère du monde*.[12] *Distinction*, famous for violating the conventional view that cultural taste was a realm of individual freedom rather than social determination, presented a picture of France as sharply unequal but still a unified symbolic space. The same set of principles governed the hierarchy from top to bottom. The sociologist's task was to decode the symbolic order (and its relationship to material inequality) as it had been to decode the order of the Kabyle house. But in *La Misère du monde*, the weight of poverty and powerlessness is apparently able to speak for itself; little decoding and little theory are necessary. The realms of social suffering, of domination, and of deculturation are implicitly presented as more transparent than life in the enchantment of social and cultural order.

* * *

Bourdieu's texts on Algeria offer something of a tragic story. There are traditional cultures, in different ways adapted to their physical environments and productive capacities, capable of reproduction so nearly perfect that they seem almost without history. To be sure, Islam swept into North Africa but without destroying traditional culture; it was absorbed (and figures only very secondarily in Bourdieu's analyses). But then French colonialism brought changes that could not be absorbed, because backed by transformative economic and state power. Many were drawn from the once stable countryside by the seductions of labor markets; others were forcibly resettled by the military. Cash transactions replaced long-term relationships; texts replaced oral traditions. Urban Arabic speakers launched a revolutionary movement against French rule, but for the Berbers it had the fatal flaw that, just like the French, it offered them citizenship only on the condition of transformation, uprooting, and acceptance of new forms of domination.[13] The housing projects of Boumediene's socialism would not be so very different from the resettlement camps of French colonialism.

In Bourdieu's texts on both Algeria and Béarn, the weight falls on the permanence of the habitus, and the consequent difficulty adjusting to new circumstances.[14] Peasants in cities cling to old ways that work poorly for them. This was both a theoretically important analysis and a significant political message. In different case studies, Bourdieu offered recurrently brilliant integration of microsociology (the nature of interaction, the practical sensibility it required) with accounts at once structural and phenomenological of how traditional culture worked (through imbuing the world with symbolic meaning and thereby generating and orienting action that would effectively reproduce a way of life). But, paradoxically, the very capacities to generate effective practical action that enabled people to deal well with traditional society were disabling in new contexts. Late in his life, Bourdieu connected his early Algerian research to his later criticisms of neoliberal globalization:

> As I was able to observe in Algeria, the unification of the economic field tends, especially through monetary unification and the generalization of

monetary exchanges that follows, to hurl all social agents into an economic game for which they are not equally prepared and equipped, culturally and economically. It tends by the same token to submit them to standards objectively imposed by competition from more efficient productive forces and modes of production, as can readily be seen with small rural producers who are more and more completely torn away from self-sufficiency. In short, *unification benefits the dominant*.[15]

Bourdieu is criticized sometimes for overestimating the unity and timelessness of Algerian societies before the French.[16] Certainly there was prior history and there were internal fault lines and occasions for debate.[17] Conversely, Bourdieu is said sometimes to overstate the completeness of colonial dispossession. If his written accounts threaten sometimes to totalize—to show traditional Kabyle society as perfectly integrated, or to show colonial Algeria only as a system of dispossession—these photographs reveal more of life outside those frames. Take one of the most "pre-interpreted" of the photos, the veiled woman riding a scooter. It is a strong image, but also a hackneyed one, reminiscent of others produced over and over around the world, the veil signifying tradition and a specifically gendered view of exotic Islam, the scooter signifying modernity. Yet although we read these meanings immediately in it, it is also a picture of a confident young woman moving about on her own.

Bourdieu initially thought his Algerian sojourn was just an interruption on the way to a career in philosophy. It marked instead a moment of personal transformation as he found his métier in sociology. In these photographs we are invited to look almost through his eyes at the world of old ways and new conditions, cultural continuity and change, that permanently and very productively gripped his imagination.

PICTURING
ALGERIA

PIERRE BOURDIEU AND ALGERIA

An Elective Affinity

The understanding view of the ethnologist with which I regarded Algeria I was also able to apply to myself, the people from my home, my parents, my father's and my mother's accent, reappropriating it all in a totally undramatic manner—for this is one of the greatest problems of uprooted intellectuals whose only remaining option seems to be the choice between populism and, on the contrary, shame and self-guilt, connected to the racism of class. I encountered these people, who are very like the Kabyles and with whom I spent my youth, from the perspective of understanding that is mandatory in ethnology and that defines it as a scientific discipline. Engaging in photography, first in Algeria and then in Béarn, definitely contributed a great deal to this change of perspective, which presupposed a veritable—and I don't think this is too strong a word—conversion of my senses. Photography, you see, is an expression of the distance of the observer, who records and never forgets that he is recording (which is not always easy in such informal situations as a village dance); but at the same time photography also assumes familiarity, attention and sensitivity to even the least perceptible details, details that the observer can only immediately understand and interpret thanks to this very familiarity, a sensitivity for the infinitely small detail of a situation that even the most attentive ethnologist generally fails to notice. But photography is equally tightly interwoven with the relationship that I have had to my subject at any particular time, and not for a moment did I forget that my subject is people, human beings whom I have encountered from a perspective that—at the risk of sounding ridiculous—I would refer to as caring, and often as moved.[1]

The photographs that Pierre Bourdieu took in the course of his ethnological and sociological research work during the Algerian war of liberation allow a new angle on his view of the social world. These photographs, which lay buried in dusty boxes for forty years, testify to a journey of initiation and a profound conversion that served as the starting point of an extraordinary scientific and intellectual trajectory.

Pierre Bourdieu's vocation as a sociologist began to crystallize at the end of the nineteen fifties, in an Algeria shaken by an exceptionally brutal colonial war and torn by anachronisms and burning social contradictions. In this, as he himself called it, giant "social laboratory" he subjected himself with increasing consciousness and methodology to a radical conversion that was founded on laborious work—in the almost analytical sense of the word—on the philosopher's habitus that his teachers at the École Normale Supérieure in Paris had sought to instill in him. In view of the crisis situations that he experienced at first hand and the omnipresent dangers with which he was faced during his years in Algeria, however, his profound aversion to the scholastic point of view and his inability to "act the philosopher" would take a critical, constructive turn.

CONTEXT OF THE EMERGENCE OF A SOCIOLOGICAL VIEW

This journey of initiation on which Bourdieu was to embark as a newly qualified philosopher, returning, four years later, as a field-tested sociologist, opened up a theoretical, empirical approach to the social world that is characteristic of his work, an approach that, being self-taught, he had to develop for the most part on his own, under exigent, dangerous conditions. In this climate of physical and symbolic violence, the young Pierre Bourdieu forged his conceptual weapons and methodological tools, which would help him, first on location and later in France, to formulate a comprehensive, coherent

theory of the social world and to test it in a wide range of research fields. This Algeria, so foreign and yet, in many respects, so like the rural everyday world of Béarn, seemed in every respect to resist the utilitarian spirit of capitalism and the one-dimensional rationality of the economic man ("business is business"), given that this largely agrarian society was still firmly rooted in traditions according to which the logic of exchange was always fundamentally founded on the principle of honor and the "ethics of brotherly love" (Max Weber). The—in every sense—violent introduction of foreign economic principles (the rapid destruction of an agricultural mode of production and the concomitant traditional relationships of solidarity, the growing economic and social precarity of wide sections of the population, and their geographical and cultural uprootedness) made this society in upheaval a particularly fascinating field of sociological observation and analysis. This raised a number of fundamental questions, such as: What happens to a society when it is confronted with radically new economic and social conditions that run counter to all of its generations-old rules? How does its characteristic traditional economic habitus limit the field of possibilities of its economic actors, trapped in their traditional logic, and how does it prestructure what is thinkable and unthinkable? What are the economic conditions for accessing economic rationality? What do such terms as *credit* and *savings* mean in such a context?

The young Pierre Bourdieu asks these questions with astonishing theoretical maturity by translating the philosophical questions that arose during his studies at the École Normale Supérieure into empirical sociological questions. He incorporates his philosophical knowledge into an analysis of interdependences between economic structures and temporal structures. His interest in the phenomenology of emotional structures, the subject of his doctoral thesis, planned but never written, manifests itself in an analysis of forms of suffering that result from the clash of mental and emotional dispositions—the habitus of the social actors—and the economic and social structures imposed by colonial society.

A "CASUAL" SOCIOLOGIST

Having the feeling of being left empty-handed in view of this vast social laboratory in a state of war, which made field research a veritable adventure, Bourdieu threw himself with total commitment into his work, experimenting, testing, and using all possible ethnological and sociological research techniques. From participant observation to depth interview, from reconstructing kinship systems to analyzing the Kabyle house as the architectural implementation of cosmological views and classifications of the world, from the statistical survey of household and time budgets that he carried out with his friends working for INSEE, the French statistics office, from systematic observation of modes of gender-specific division of labor and the associated forms of male domination to analyzing the logic of gift exchange, from creating topographical sketches of the physical space of a Kabyle community to the systematic use of photography as an instrument of documentation and testimony—all research techniques, all methodological approaches and instruments were put to the service of untiring field research work. As a firm opponent of French colonialism and military oppression, Bourdieu saw his research in the compass of a radical political and committed approach: He wanted to bear witness to all that he saw, to understand a totally unsettled social world rife with contradictions and anachronisms. In view of the unbearable violence of what he was seeing, he found his sole refuge from sheer desperation in reflective detachment and a stance that he would later refer to as "participant objectivation."

This committed objectivation also corresponds to his way of using the photographic lens: materializing and memorizing observations. But these images of Algeria, as we see them today, have attained another function, for they can also serve as a mirror. Our contemporary societies are faced with a brutal neoliberal radicalization of capitalism and its market-economy logic. By visualizing such social contexts, these photographs help us better understand the dimensions and consequences of current economic and social upheavals that are affecting more and more sections of the population. They

too are faced with a new economic logic, which demands completely flexible and mobile labor innocent of history and ties, a logic that simply cannot be reconciled with their fundamental thought and action schemas. The parallel between the "deruralized" farmer from Kabylia and the damaged, deregulated employee of today's capitalist societies is obvious, and we need only compare the testimonies presented in the collective work *The Weight of the World* supervised by Pierre Bourdieu with the testimonies summarized forty years before in the two works *Travail et travailleurs en Algérie* and *Le Déracinement*. It is quite credible, then, when, toward the end of his life, Pierre Bourdieu said of his Algerian research: "This is my oldest and at the same time my most current work."

However, this implies that we are dealing with a societal and political question of pre-eminent topicality; a topicality due not least to a sociological objectivation made possible by a militant use of photography. Pierre Bourdieu's photographs are being made accessible to the public for the first time here—not counting the few pictures used to illustrate the covers of some of Bourdieu's works. Here we see Bourdieu's view, a sociological view common to all the pictures. At the same time, however, the view is a profoundly political one. As Pierre Bourdieu emphasized on many occasions in our conversations, he saw his photographs not only as testimonies, but as a form of political commitment: seeing in order to make something visible, understanding in order to make something understandable.

IMAGES OF ALGERIA: A BOOK—AN EXHIBITION

At the end of this introduction it seems appropriate to mention the various stages in realizing this project. When the book *Algérie 60*[2] was being prepared for German publication in 1999, Pierre Bourdieu told me of his ethnological and sociological work in Algeria in the late 1950s and of the hundreds of photographs that he had taken at that time. After several conversations about

this period and about the key role of his Algerian research with regard to the development of his theory of the social world, he finally showed me a few hundred of his pictures—the others, according to his estimate around one thousand photographs, had been lost in the course of several moves. Noticing my great interest in the photographs with regard to my attempt to reconstruct this Algerian experience, he finally consented to having them made accessible to the public at an exhibition and in a book, despite all the hemming and hawing to be expected in view of Pierre Bourdieu's modesty and shyness.[3] In the end, we found the ideal partner for this project in Camera Austria, as this artists-founded institution held all the important cards in the field of artistic photography and *Camera Austria International* photography magazine had already published interviews with Pierre Bourdieu. The aim was for Bourdieu to play the role of ethnographic informer in our collaboration, and to "frame" the photographs in their chronological, geographical, and thematic contexts. At the same time, the pictures were to serve him as *aide-mémoires* for a biographical reconstruction of these crucial years of his life. Pierre Bourdieu was able to accompany this project until autumn 2001, after which, to our great dismay, we were forced to complete the work without him. We tried to stick as closely as possible to the meaning that, according to his comments in various conversations, he had wanted to give to this project. In the form of a book and an exhibition that opened on January 23, 2003, exactly one year after his death, at the Institut du Monde Arabe in Paris, as a kind of sneak preview, and then, officially, on November 14, 2003 at the Camera Austria exhibition space at Kunsthaus Graz, we were able to make this photographic work accessible to the public so as to pay tribute to Pierre Bourdieu and to express how important he remains for us.

Franz Schultheis

PICTURES FROM ALGERIA

An Interview with Pierre Bourdieu[1]

FRANZ SCHULTHEIS

COLLÈGE DE FRANCE, PARIS, JUNE 26, 2001

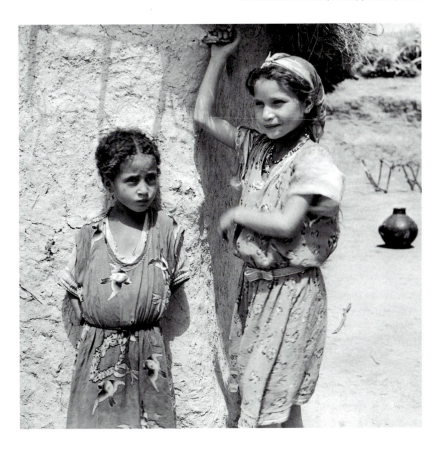

Franz Schultheis: Pierre Bourdieu, when you agreed to allow us to view the photographs that you took during your stay in Algeria, and that had been lying in boxes for forty years, you also promised to give us an interview about your use of photography for your ethnographic field research and sociological studies on site. Let us start with a very down-to-earth question. What camera did you use to take the photos in Algeria?

Pierre Bourdieu: It was a camera that I had bought in Germany. A Zeiss Ikoflex. Unfortunately, the camera got broken on my trip to the United States in the seventies, which I regretted very much. If I find the time, I sometimes have a look around second-hand photography shops to see if I can find the same camera again, but several people have already told me that you cannot get hold of it any more. The Zeiss Ikoflex cameras were the cutting edge of technology in Germany at the time. That's where I bought mine. It must have been the first year I started earning my own money (I was appointed professor in 1955). Incidentally, I think I smuggled it to France. . . . It had a very special lens, which is why it was so expensive. Apart from that it was identical to the classical Rolleiflex model with the viewfinder on top of the body. . . . That was very useful to me because there were often situations in Algeria where it was very ticklish to take photographs, and this way I could take them without anyone noticing. For example, I also had a Leica; I had friends in Algeria who were professional photographers, and I asked them for advice, as one of the problems in Algeria is the very, very bright light that destroys every picture, so I needed their advice. Well, almost all of these friends used a Leica; that was the usual camera for professionals at the time, but it means that you have to be standing opposite the person you are photographing. But often enough that was not possible—for instance, if you wanted to photograph a woman in a country where that is frowned upon, etc. In some cases, I got a permit—for example, during my field research in the Collo or Orléansville regions. So, of course, I took a lot of photos there, and the people were happy about it. These photos also include a series of pretty dramatic pictures of a circumcision—the father asked me to take them: "Come and take some

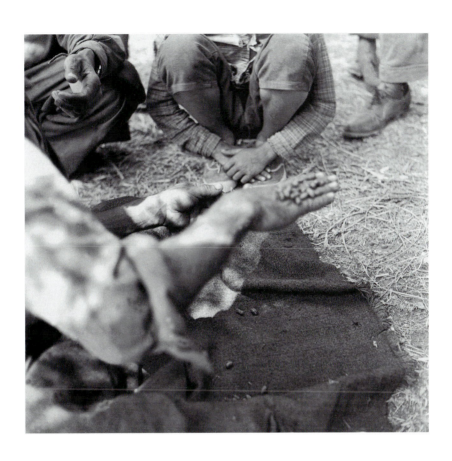

pictures." Photography was a way of relating to people and of being welcome. Afterwards I would send them the photos.

F.S. Did you develop these photos yourself?

P.B. I only bought all the equipment much later, because all of my photographer friends said, a real photographer develops his own photos, because only while you are developing do you see the true quality of the photos, and you can work with the material, blowing up specific details, for example. I was not able to do it at the time, but I did have a little photo lab in Algiers that worked pretty quickly, and I could tell them exactly what I wanted. I had contact prints made and little positives; later on I talked with the man from the lab a bit longer and I ordered some more complicated things. Because I was taking a lot of photos at the time, he was very interested and I gave him a free hand, although I did always try to keep control of everything as well, after a fashion.

F.S. In a way, you were already fascinated by photography even before you left for Algeria. Had you been planning to make systematic use of photography during your stay? Was it a proper project?

P.B. I took this thing very seriously; I started notebooks, sticking the negatives in them, and I had shoeboxes that I sorted the film material into. And then I bought little celluloid bags and put the photos in them, writing a number on each of them and then entering the number in the notebook with the negatives stuck in them. But I had a problem: Should I keep all the film material? I tended to keep a lot because the material had two functions: a documentary function, on the one hand. Sometimes I would take photos for the simple reason of being able to remember something, later to be able to describe it, or I would photograph objects that I couldn't take with me. But there was something else, too: Photography was—how can I put it—a way of looking. There is this petit bourgeois spontaneous sociology (that petit bourgeois writer Daninos in France, for example) that makes fun of people who set out on their tourist excursions with cameras over their shoulders and then do not even really see the landscape because they are so busy taking photographs. I always thought that was class racism. In my case, at least, it was

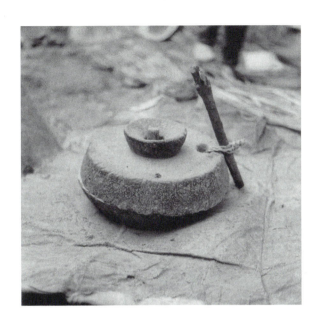

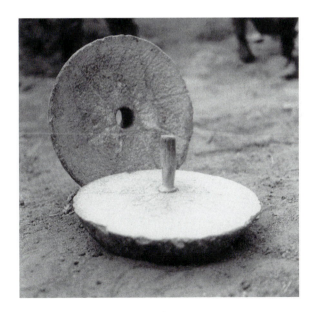

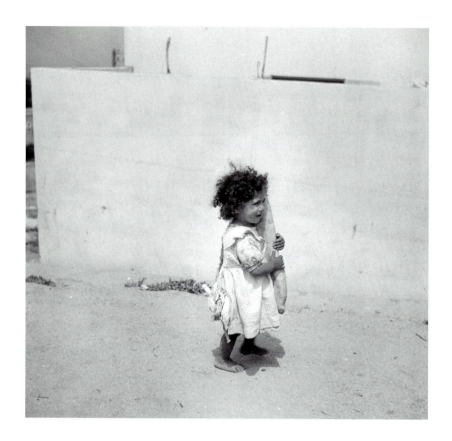

a way of sharpening my eye, of looking more closely, of finding a way to approach a particular subject. . . . During my years in Algeria, I often accompanied photographers doing photo reportages, and I noticed that they never spoke to the people they were photographing; they knew next to nothing about them. So there were different kinds of photographs. For example, there was a marriage lamp that I photographed so that I could study how it had been made later on, or a grain mill, etc. On the other hand, I took photos of things that appealed to me. I remember a photo of a little girl with plaits, with her little sister standing by her side. You might have thought it was a fifteenth-century German Madonna. Or this other photo I really like too—I

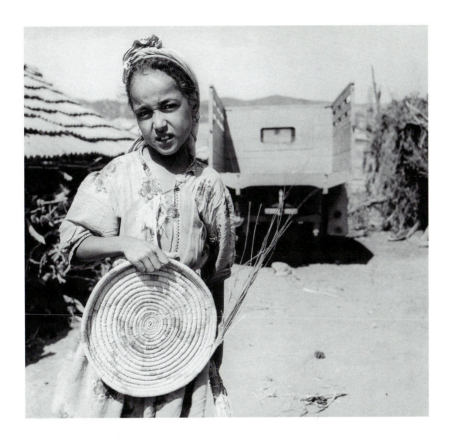

still remember, it was on the outskirts of a slum—it is a picture of a little girl who was just about 80 cm tall; she was carrying a loaf of bread pressed against her belly; it was almost as big as the girl. The photo is very sober and reserved; the girl stands out against the white wall that she is standing in front of.

F.S. And when did you start taking photos systematically? Was that after your military service?

P.B. Yes, exactly. It was in the late fifties. I had the idea to take photos of situations that really touched me because different, dissonant realities merged into each other in them. I particularly like one of these photos: It is a picture

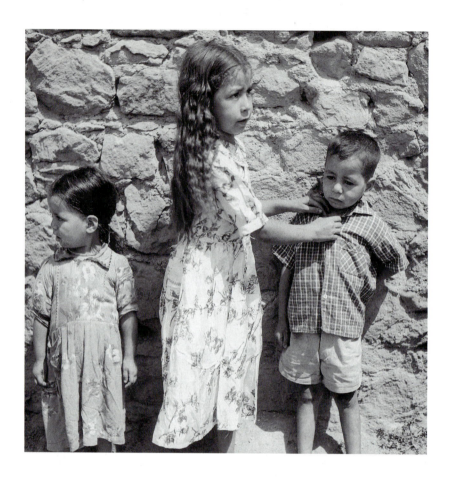

I took in broad daylight in Orléansville in summer, at one of the hottest spots in Algeria. The picture is of an advertising sign for a driving school, with a road winding its way between fir trees, and an advertisement for refrigerators right next to it. I was amused by this kind of mixing of realities. I used another very typical photo for the cover of the book *Algérie 60*.[2] It's a picture of two men wearing turbans—really traditional Arabs—sitting on a car bumper (incidentally, a bit further back you can see my own car, a Renault Dauphine); so these men are sitting there, deep in a serious conversation.

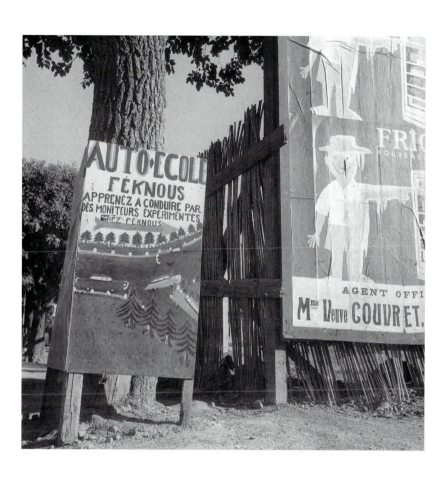

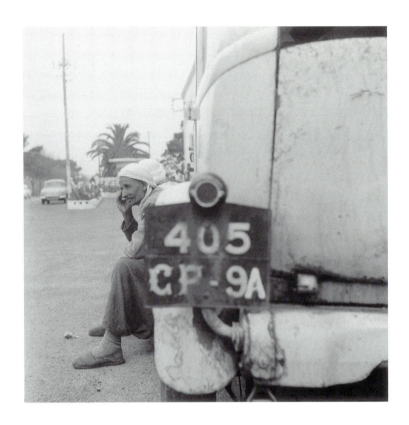

F.S. If you look at these photos, you are faced with the following question: You can tell that they are not tourist photos, but photographs that were taken very consciously. So the photos have a very specific purpose. You say to yourself that you took photos in order to objectify, to create a distance, or to make time stand still for a moment. The thought would seem to suggest itself, then, that there is an intrinsic link between the objectification achieved by means of the photographic view and the ethnological approach you were developing at the time as a self-taught ethnologist, and that both views—the ethnologist's or anthropologist's and the photographer's—have an elective affinity.

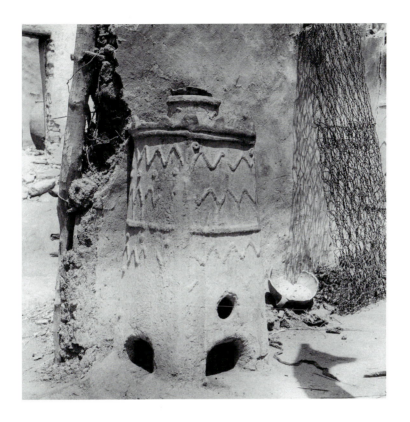

P.B. Yes, I am sure you are right there; in both cases there was this objectifying and loving, detached and yet intimate relationship to the object, something similar to humor. There are a number of photos that I took in the Collo region, in a pretty dramatic situation. I was in the hands of people who had the power over life or death—my life, but also the lives of the people who were with me. It is a series of pictures of people sitting, discussing and drinking coffee under a big olive tree. In this case, taking photos was a way of saying to them, "I'm interested in you, I'm on your side, I'll listen to you, I'll testify to what you're going through." For example, there is another series of photos, which are not particularly aesthetic, that I took in a place called Aïn Aghbel

and in another place called Kerkera. The military had herded people together who had previously been living scattered around the mountains and resettled them in terraced houses styled on a Roman *castrum*. Against the advice of my friends, I had set out into the mountains on foot to look at the destroyed villages, and I found houses that had had their roof taken off to force people to leave. They had not been burned down, but they were no longer habitable. And I came across clay pitchers in the houses (something I had already begun researching in a different village, Aïn Aghbel: There are places where everything we would call furnishings is made of fired clay, made and shaped by the women); in Kabylia they call them *aqoufis*, those big clay grain pitchers decorated with drawings. The drawings are often of snakes, snakes being a symbol of resurrection. And although the situation was so sad, I was happy to be able to take photographs—it was all so contradictory. I was only able to take photos of these houses and immovables because they had no roofs any more. . . . This is very characteristic of the experience I had there, a quite extraordinary experience. I was very moved by and sensitive to the suffering of the people, but at the same time I had the detachment of an observer, as manifested by the fact that I was taking photos. All this came to mind when I was reading Germaine Tillion, an ethnologist who worked on a different region in Algeria, Aurès; in her book *Ravensbruck* she relates that she was forced to see people die in a concentration camp, and every time someone died, she made a notch. She was just working as a professional ethnologist, and in her book she says it helped her keep going. So I thought about this and I said to myself, "You're a funny guy": It was here, in this village with the olive tree, that people started talking to us on the first day after our arrival— no, not the first day, it was the second day, the first day was much more dramatic, but I won't go into that here, it would sound like heroic pathos; so on the second day after we arrived they started telling us things like: "I used to have this, I used to have that, I had ten goats, I had three sheep." They enumerated all the things they had lost, and I wrote down as much as I could, together with three other people. I recorded the catastrophe, and at the same time I intended to analyze it all with the methods available to me with a kind

of irresponsibility—and that was really a scholastic irresponsibility, I realize that in retrospect—while I would always say to myself: "Poor Bourdieu, with the pathetic instruments you've got, you're not up to it, you would have to know everything and understand everything, psychoanalysis, economy. . . ." I performed Rorschach tests, I did what I could to understand—and at the same time I intended to collect rituals—for example, the ritual at the start of spring. And these people told me stories, stories of man-eaters, and they told me about the games they always played: They took some olives from the olive tree under which they were sitting, olives that were not yet fully ripe, and they threw them up into the air. Then you have to catch them on the back of your hand and, depending on how many olives you drop, someone hits you with three or four fingers. Under that olive tree I interviewed guys between thirty and fifty years old, and some of them had a weapon concealed under their *djellaba*. So they would play there (if you dropped two, you got hit with two fingers; if you dropped three, then with three fingers), and they hit very, very hard, playing like children. Now that's something very typical of my relationship to this country. It is extremely difficult to speak about all of this in the right way. It was far from being a concentration camp. The conditions were dramatic, but not as dramatic as was often claimed. And I was there and I saw it all, and it was all so complicated and went far beyond my means! When they told me things, it would sometimes take me two or three days to understand it all, complicated names of places or tribes, numbers of lost cattle, and other lost commodities, and I was totally overcome by it all; in this respect any help was good, and photography was really a way of trying to come to terms with the shock of this devastating reality. There was a place there, very nearby, called Kerkera, a vast place that they had built up right in the middle of a swampy plain that people could not cultivate as they did not have any plows or work animals that would have been strong enough. So they settled people there, two or three thousand of them; it was vast, and this kind of suburb without a city was really tragic. I did the most crazy thing in my life there: a consumer study styled on the INSEE, the French National Institute for Statistics. A consumer study is a very time-consuming affair. You turn up

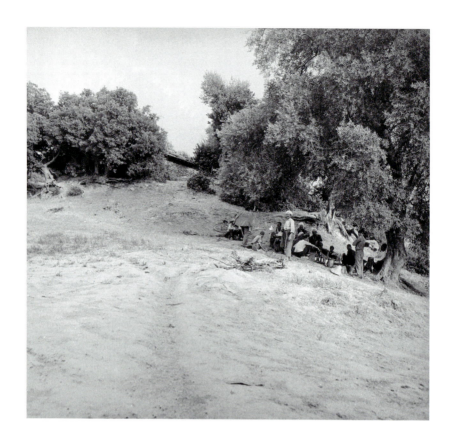

with your questionnaire and you ask people, "What did you buy yesterday?" Candles, bread, carrots. . . . They list everything and put a cross next to yes or no. They come again two days later, three times altogether. It was a vast task to organize and conduct such a study in such a difficult situation—even if I was not alone, there were three or four of us. This whole study did not lead to any special results except for the fact that this population, which seemed to be totally destroyed, homogenized, leveled, and reduced to the lowest level of poverty, displayed a normal distribution—there were all the differences that you find in a normal population, a normal distribution.

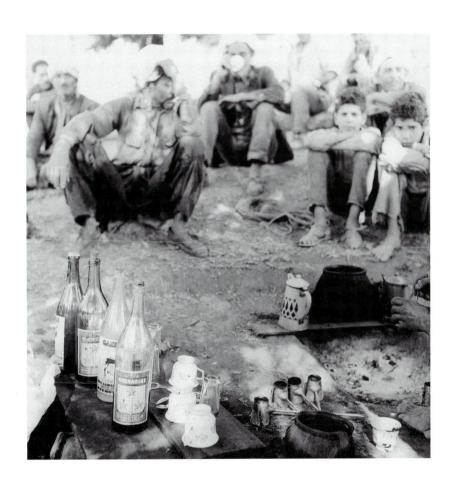

F.S. Listening to you, I get the impression that you were not pursuing a specific project but rather that you were going in various directions and that you wanted to go through the whole spectrum of sociology in a very short period.

P.B. Yes, but what could we have done differently? What do you do when faced with such an overwhelming, oppressive reality? Of course there was a risk of being overwhelmed by it all and of creating a completely mad chronicle trying to recount everything. One of the great mistakes I made was not to keep a diary. I had all these separate scraps, everything was totally chaotic—it was all just very difficult, we had little time, and it was very exhausting.

F.S. A specific question: Although you did not keep a diary, I am fairly sure you could locate everything very quickly and very reliably if you were to look at the photos, and if you saw the little girl sitting on the ground you could definitely say, "Oh yes, that was here or there," couldn't you? So the photos are memory aids, that are very. . . .

P.B. Yes, I can definitely say that was in Orléansville, that was in Cheraïa. . . .

F.S. So these memory aids are very important, and you would have to see whether, based upon them. . . .

P.B. I should have done that . . . but I just didn't have the energy for it. We worked from six in the morning until three in the morning; it was simply unthinkable. Sayad was the only one who stuck it out; the others were totally shattered; it really was a tough time.

F.S. To come back to the question of the perspective: The focus is on emotional aspects, and then there is the rift that is very important to you, a rift between a world about to disappear, with its familiar forms, and a new world that is becoming established very quickly. That is to say, the nonsimultaneity of the objects. What structures the sociological perspective in your book Travail et travailleurs en Algérie[3] *seems to be the vast difference between time structures and economic structures, and one might say that the same leitmotifs can be found in your photos, i.e., in the photographic perspective of the social world. . . .*

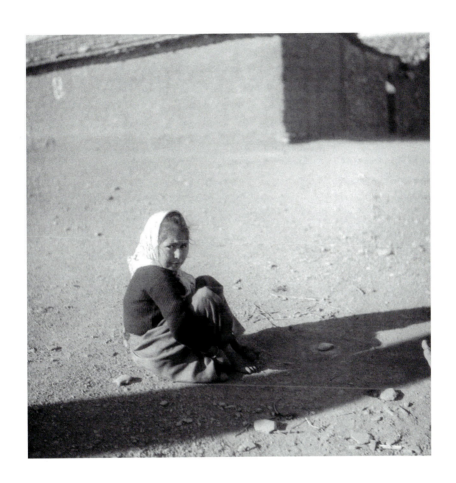

P.B. There is a photo that is very typical of this that I used for the cover of *Travail et travailleurs en Algérie*. It's a picture of farm workers on the Mitidja plain near Algiers. They are working in line, spraying sulfate that is being pumped through a hose linking them to a machine transporting the sulfate. Five or six of them are moving forward, perhaps more. The picture is a very good portrayal of the circumstances of these people and, at the same time, you see the industrialization of farm work on these big colonial farms that, compared to the French farming industry, were very advanced. I spoke briefly with some of these people, who earned a pittance as farm workers and who worked their own little plot of land on the edge of the big estates. . . .

F.S. In view of what you have said about the way you conceived and took these photos, I wonder what might be an adequate form of reception and presentation. The important thing is to create a link to your ethnological research and the books about your beginnings, when you were analyzing the same subject that we see in your photos. Although it would seem appropriate to link up these two aspects, at the same time I would be a bit chary of doing so, as this would, at first glance, appear to be an even more spontaneous and simplifying approach than simply looking for descriptions of situations in the texts, stories that remind us of what the photos depict.

P.B. It is perfectly natural to link the content of my research and my photos. One of the things that interested me most in Algeria, for example, is what I called the "economy of poverty" or the "economy of slums." Normally, the slums were perceived (not only by racist, but also by naive observers) as something dirty, ugly, disorderly, thrown together, etc., whereas, in truth, it is a place for a very complex life, for a real economy with an inherent logic, where you see a great deal of resourcefulness, an economy that at least offers a lot of people a minimum with which to survive and, above all, for social survival—i.e., to escape the shame for a self-respecting man of doing nothing and contributing nothing to his family's livelihood. I took a lot of photos on this subject, photos of all the hawkers and street vendors, and I was really amazed at the resourcefulness and energy in these unusual buildings, that were reminiscent of shop windows or a shop; or this motley collection of

displays on the ground (which also interested me from an aesthetic point of view, as it was a very baroque scene); the pharmacists I interviewed, who were selling almost all sources of traditional magic, whose names I wrote down, aphrodisiacs, etc.

There were also very picturesque butcher's shops (those three big, triangular wooden stands with cuts of meat hanging on them)—a typical subject for a photographer in search of picturesque, exotic scenes. I myself always had hypotheses about the organization of space on my mind: There is a layout plan of the village with a certain structure, a structure of a house; and I also discovered that the distribution of graves in the cemetery corresponded roughly to the layout of the village based on clans. And I wondered, "Will I find the same structure in the markets?" That reminds me of a photo I took in a cemetery: a Cassoulet tin filled with water on an anonymous grave. On the seventh day after someone has died, you have to bring water to their grave in order to capture the female soul; in this case it was a Cassoulet tin that had previously contained a taboo product: pork.

F.S. When you returned to France, you very soon began your research on photography.[4] How did you arrive at that idea? Was it someone else who gave you the idea?

P.B. I do not remember exactly, and I would not want to tell you any nonsense. But I do know that it was connected with the fact that Raymond Aron appointed me director of the general secretariat of a research center that he had just founded. I was not particularly self-confident in those days and I thought that it would be a good thing to get another source of income; in case I was not very successful, then it would not be that bad if. . . . So I signed a contract with Kodak. Photography is a subject that I was very interested in. Of course, what I had in mind was the fact that photography is the only practice with an artistic dimension that is accessible to everyone, and at the same time it is the only cultural asset that everyone consumes. I wanted to take this indirect approach to arrive at a general aesthetic theory. It was both a very modest and very ambitious undertaking. People tend to say that photos of the common people are terrible, etc., and at first I wanted to understand why that was;

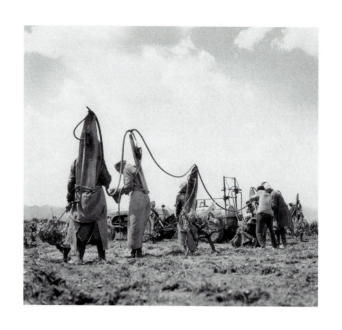

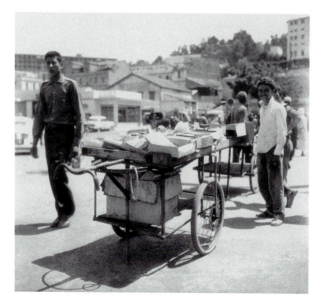

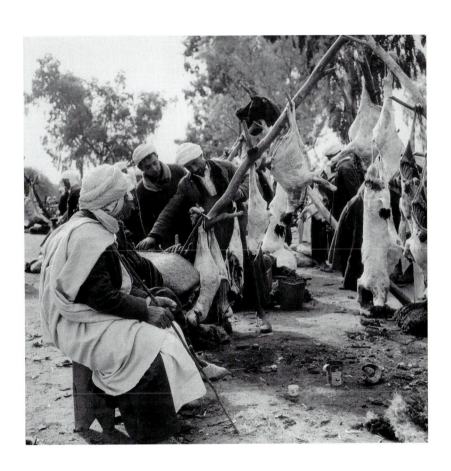

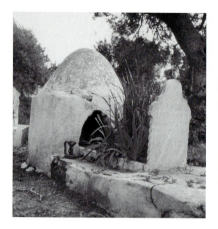

I wanted to try and do justice to the fact, for example, that these pictures are usually taken face on, that they depict relationships between people—these things that gave the whole thing a certain necessity, that also had the effect of rehabilitation. What I then did was to analyze a collection of photos, the collection of my childhood friend Jeannot. I took one photo after another, totally soaked them up, and I think I found a great deal of things in this shoe box.

F.S. But as you said, you already observed professional photographers when you were taking photos in Algeria, and you said to yourself, "I wouldn't have taken that photo" or, "I would have done it differently," or sometimes, "I would have done it exactly the same way." So there was already a reflectivity in your dealing with photography, a kind of beginning, a point of departure for reflection. . . .

P.B. Yes, that's right. But if the professional photographers did sometimes take photos that I would have liked to have taken too, photos of the strangest things, they also did a lot of things I would not have done, things that just looked painterly. I think—apart from occasional flukes—it was not easy for them to take an unconventional view of this society, a view that was not exclusively picturesque by design: a weaver at work, women coming home from the well.

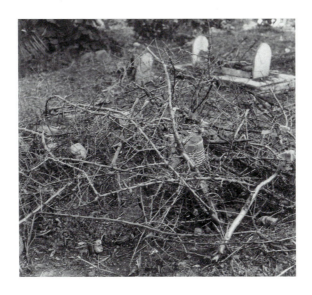

One of my "most typical" photos is of a veiled woman on a moped—it is a photo they could have taken as well. That is the "easiest" aspect of what I wanted to understand. There is an anecdote that sums up my experience in this country very well (a strange country in which I had a constant sense of tragedy—I was very scared, at night in my dreams as well—and yet I saw a lot of funny things too that made me laugh or smile); it is a story that expresses this dual, contradictory and ambivalent experience very well, an experience that I always found very hard to express or convey here in France—indeed, it was even difficult in Algeria with the bourgeois Algerian town-dwellers; I am thinking about a young student from an important family of the Kou-louchlis who took part in our studies of the urban milieu (she wrote to me just recently), and who could not conceal a certain feeling of fear mixed with disgust in view of the people who would often touch me in a rather ridicu-lous, pitiful attempt to stage or underline their poverty and misfortune. (That is why I liked the way men like Mouloud Farraoun would look when he was telling me of his disputes with schoolchildren's parents, or the way Abdel-

malek Sayad would often look at the people we met with amusement and yet slightly touched). But to get back to my story; I was just driving out of a parking space one day, when along came a young veiled woman who saw me hesitate to drive my car out, and she turned round and said to me under her veil: "Well then, darling, are you going to knock me down?!"

F.S. You know, that reminds me a bit of a comment by Günther Grass that you will no doubt remember. He said, "Sociology is too serious." But that's not true! Not at all! He just didn't understand that it would have been out of place to work with humor in view of The Weight of the World.

P.B. In *Le Déracinement*, too, which is very similar to *The Weight of the World* in many respects, there is little room for this amusing side of things. Incidentally, if I were to look for a literary model with which to express such terrible experiences to the point of their humorous aspects, I would rather think of Arno Schmidt. I often regret not having kept a diary. I devoted myself fully to my "duty" as a researcher and witness, and I did my best to pass on these extraordinary and—sadly!—universal experiences with the resources available to me, experiences that are always linked to flight and wars of liberation. Also, I was not satisfied to bear witness to it all in the manner of a good reporter; rather, I wanted to work out the logic and transhistorical effects of these sweeping compulsory resettlements of the population. And then there is the censorship of academic decency according to which there are many things that you would not even think of talking about. And thirty years ago I probably would not have been able to tell you what I am telling you at the moment, or I would have said it but not in the same way as I dare to say it today.

F.S. You can afford to today. Your work exists, and now you can go back into the past and uncover things that were previously hidden.

P.B. Being worried about having to be sufficiently serious and scientific induced me to withdraw myself to a great extent with regard to the literary side of my work. I censored a lot of things. I think that during the early days of the Centre de Sociologie Européenne there was a tacit exhortation—if not an explicit rule—to delete everything that was philosophical or literary. You had to respect the tacit rules of the group. Anything else seemed to be inap-

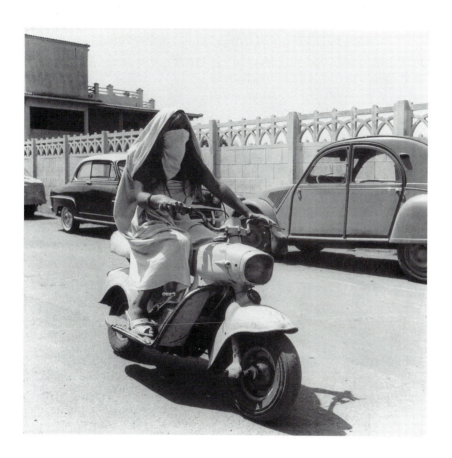

propriate, narcissistic, self-satisfied. Today I often regret that I was not able to retain the useful traces of this experience. I did experience a lot of things that put me apart from my intellectual contemporaries. I got older a lot faster. . . . Yes, it's true, I should try to look at the photos one day and dictate all my thoughts on tape.

F.S. *Before we finish, I would like to ask you a personal question: In your opinion, what role does your experience in Algeria play in the context of social self-analysis, which you outlined in your last course at the Collège de France?*

P.B. Yvette Delsaut wrote a text about me in which she very rightly says that Algeria is what allowed me to accept myself. With the same perspective of understanding of the ethnologist with which I regarded Algeria, I could also view myself, the people from my home, my parents, my father's and my mother's pronunciation, reappropriating it all in a totally undramatic manner—for this is one of the greatest problems of uprooted intellectuals when all that remains to them is the choice between populism and, on the contrary, shame induced by class racism. I encountered these people, who are very much akin to the Kabylians and with whom I spent my youth, from the perspective of understanding that is mandatory for ethnology, defining it as a discipline. Photography, that I first began doing in Algeria and then in Béarn, definitely contributed a great deal to this conversion of my perspective that required a genuine change of my senses—which is no exaggeration.

Photography, you see, is a manifestation of the distance of the observer, who collects his data and is always aware that he is collecting data (which is not always easy in such familiar situations as balls), but at the same time photography also assumes the complete proximity of the familiar, of attention, and a sensitivity with regard to even the least perceptible of details, details that the observer can only understand and interpret thanks to his familiarity (and do we not say that someone who behaves well is "attentive"?), a sensitivity for the infinitely small detail of an act that even the most attentive of ethnologists generally fails to notice. But photography is equally interwoven with the relationship that I have had to my subject at any particular time, and not for a moment did I forget that my subject is people, human beings whom I have encountered from a perspective that—at the risk of sounding ridiculous—I would refer to as caring, often touched.

That is the reason I never stopped conducting interviews and observations (I always started my research with them, no matter what the subject), which broke with the routines of bureaucratic sociology (which I see embodied by Lazarsfeld and the Bureau of Applied Social Research at Columbia University, who introduced Taylorism into research), a sociology that only has access to its interviewees through intermediary interviewers and that, unlike even

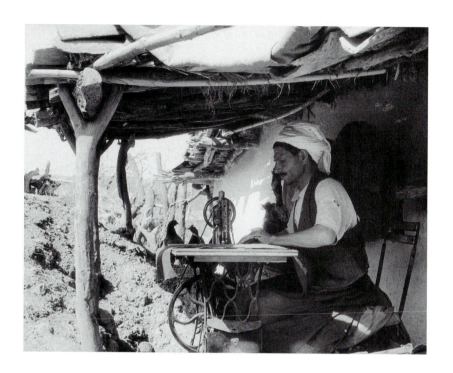

the most cautious ethnologist, has no opportunity to see the interviewees or their immediate environment. The photos, which you can look at again and again at leisure, like sound recordings that you can listen to again and again (not to mention videos), allow you to discover details that escaped you at first glance or that you cannot examine at depth during an interview for reasons of discretion (during the studies for *The Weight of the World*, for example, the furnishings of the metalworker of Longwy or of his Algerian neighbor).

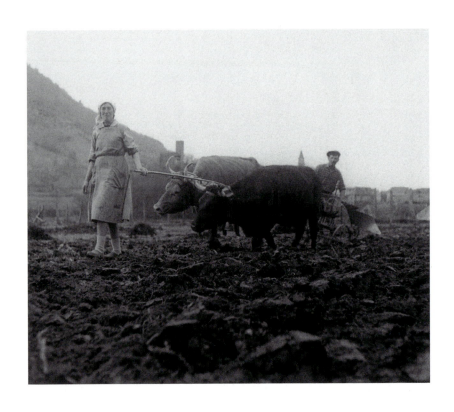

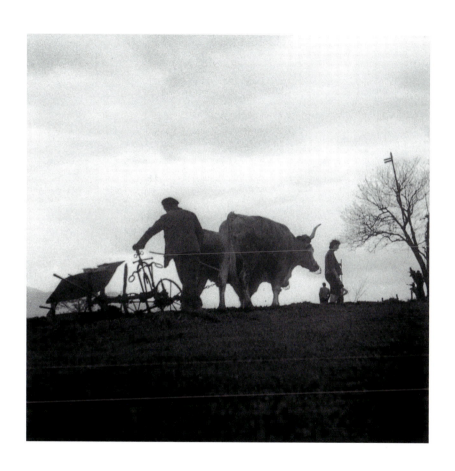

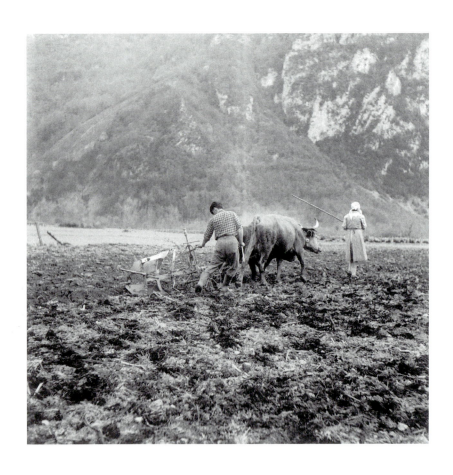

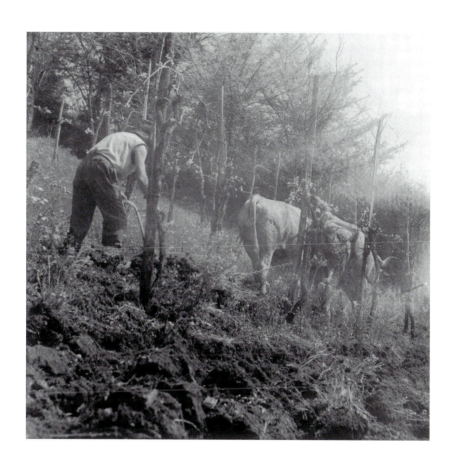

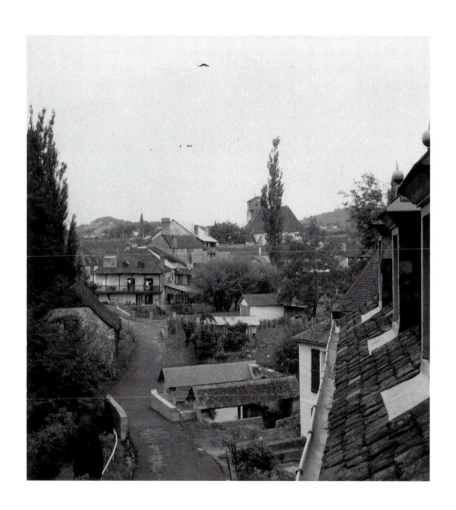

WAR AND SOCIAL
TRANSFORMATION
IN ALGERIA

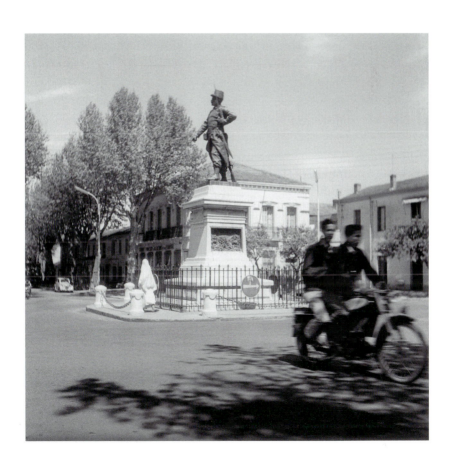

In sociological terms, the war has brought about two different types of change, which should not be confused. On the one hand, there are the sociological mutations entailed by the very fact that the war *exists*; on the other, the upheavals and disruptions resulting from the way it has been conducted, the consequent cultural shock waves, and the political and military measures that have been taken.

Let us look, to begin with, at the former type of change. The fact is that the existence of the war has led not only to a profound remodeling of the sociological domain in which behavior patterns are acted out, but also to a change of attitude on the part of the individuals involved, with regard to the situation itself. From a sociological point of view, this is undoubtedly the most important event to have taken place in Algeria for a hundred and thirty years. It is as though a society that had chosen, more or less consciously, to be static and inward-looking, and that had set up a thousand invisible but impregnable ramparts against the intrusion of anything new, were suddenly opening up, suddenly moving again. How is one to interpret an abrupt, generalized change like this, attested to by a multitude of details?

The war constitutes the first radical challenge to the colonial system, and, more important still, the first one that is not, as in the past, *symbolic*, but in a certain sense magical, though also real and practical. There are a number of cultural traits, such as an attachment to certain customs, values and items of clothing (the veil, for example, or the fez), that might appear as ways of expressing, symbolically, i.e., through activity implicitly charged with the function of *signs*, a rejection of Western civilization (insofar as it is identified with the colonial order), along with a resolve to retain one's identity; to assert a fundamental, irreducible difference; to oppose any negation of the self; and to defend a threatened, beleaguered personality. In the colonial situation, any renunciation of these cultural characteristics and their value as symbols would have signified, objectively, an abjuration of the self and an acceptance of allegiance to another civilization.

Perhaps the crucial sociological fact is that the war is actually tantamount to a language. It has given the people a voice; and the voice is saying "No."

Thus it is that between the members of the subordinate class and those of the dominant class there is always another presence, which Raymond Aron, somewhere or other, called "the third man." And the result is that the charm of the tête-à-tête is vitiated. The dominant-subordinate relationship has lost its essential purity. The logic of humiliation and contempt has broken down.

At the point where radical negation insinuates itself into the very heart of the system—real, concrete, daunting, capable of plunging the great French nation into doubt, generating uneasiness and anxiety among Europeans who had hitherto been so assured and confident; triggering ministerial crises, debates at the United Nations, programs, conferences and speeches, visits by ministers and foreign observers, so that the entire world finds itself compelled to recognize the existence of this negation—the magical denials and symbolic refusals lose a good deal of their function and significance.

And so Algerians can now take responsibility for their own decisions, and for all that they have borrowed from Western civilization. They can admit (even to themselves, as one of them said to me with a smile) that they are "integrated." They can proclaim, without contradiction, that they adhere to the values of Western civilization and its lifestyle. They can go so far as to reject—without rejecting themselves—a part of their cultural heritage. Negation remains permanent and unchangeable. Colonial traditionalism had an essentially symbolic function: It acted, objectively, as a language of refusal. Given the fact that negation exists in things themselves, as the sum of all the individual refusals, the West can be accepted without any suggestion of obeisance.

The most manifest and spectacular renunciations may be those that concern traditions permeated by an intrinsically symbolic value, such as the wearing of the veil or the fez. But a new sense has been added, like a graft, to the traditional function, by reference to the colonial context. Without pushing the analysis too far, it can be seen, in effect, that the veil is first and foremost a defense of privacy and a protection against intrusion. And the Europeans have dimly recognized it as such. The veil allows Algerian women to create a situation of nonreciprocity. It is a form of "asymmetry" whereby

they can see without being seen, without making themselves visible. And it is the entire subordinate society that thereby spurns reciprocity. It scrutinizes, observes, and penetrates without being scrutinized, observed, or penetrated. Europeans often indignantly inveigh against this unfairness that gives Algerians a direct form of access to Europeans, whereas the opposite is not the case. And the veil may thus be seen as a sign of withdrawal into oneself. For a number of years, young Algerian women showed a tendency to abandon it. But after May 13, 1958, there was a slowing down of the tendency, and then a turnaround. The wearing of the veil regained its sense of symbolic negation. Giving it up could now be seen as a sign of allegiance. And at present, a clear recrudescence of the movement is taking place, even in the countryside.

This general shift in attitudes also comes through in other areas. Rightly or wrongly, the members of the subordinate caste regarded some institutions as being aligned with the colonial situation, and as a result were extremely wary of them. Education and medicine, for example: The relationship between doctor and patient, or teacher and student, was seen as being representative of the colonial situation, from which it drew its meaning. The doctor's prescriptions and the schoolteacher's lessons could intuitively be felt (without the basis for this feeling necessarily acceding to consciousness) as attempts to impose the norms of a foreign civilization.

But in recent years, resistance and hesitation have given way to an extraordinary thirst for education that the provision of schools has brought to the forefront, and that has also been made manifest by a number of other signs.[1] In spite of a major drive to provide more facilities and teachers, the number of children for whom there are no places in the schools remains, as we know, very high. And primary school teachers, especially in the towns, are besieged by parents demanding that their children be enrolled. Education for girls, which until recently was strongly resisted, is now a subject of great interest, just as much as education for boys.

But the central fact, perhaps, is that what was formerly seen as an imposed constraint, or a free gift, is now claimed as a right. This is evidently the case for those parents who want to get their children into schools, and for the

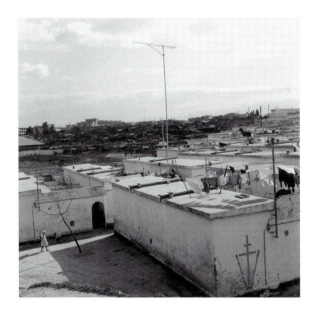

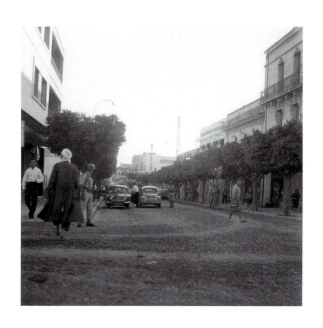

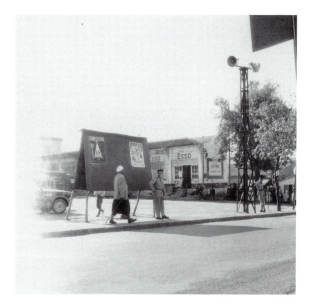

women who flock to the community centers every morning. The position of the petitioner who humbly solicits a favor has given way to an assured assertiveness that takes health care and other services as entitlements.

Devoted submission was vaguely linked to an attitude of abdication motivated by a feeling, whether acknowledged or not, that Europeans were inimitable and incomparable, either de jure or de facto. The members of the subordinate caste sometimes admitted, at least implicitly, if not voluntarily or consciously, that differences in status expressed differences in nature. But is this not only to be expected, after all, in a situation where the nature of the social order is such that relationships between the members of the subordinate caste and their superiors—employers, doctors, teachers, policemen— are superimposed on, and inseparable from, relationships with Europeans?[2] Algerians tend to construct personas for themselves as Arabs-for-Frenchmen. Those who seek jobs in French firms know that they must express themselves in a particular way, that they must arrive on time, that they must maintain a certain work rate, and so on. And the Europeans see nothing of them other than this mask, this role, which is often awkward and stilted. Algerians tend to wear their persona like an ill-cut suit, with the result that in their anxiety to be above reproach, and to fully comply with what is expected of them, they lay themselves open to accusations of dissimulation and hypocrisy. One example will suffice to illustrate the phenomenon. An Algerian man is asked to dinner at a French person's house where his mother works as a maid. Throughout the meal, she plays the part of the silent, attentive servant. But when the coffee is served, she is invited to join the guests. And then all at once she changes, like an actress leaving the stage. She assumes her full dignity and distinction. She takes part in the conversation. Everything about her is different, including the way she sits, the way she holds herself, the way she smiles.

The type of overprotective approach that leads to a society being dispossessed of its responsibility for its own destiny conduces to an attitude of resignation and indifference. And paternalism leads, at best, to its "beneficiaries" being placed in the position of irresponsible children, untrammeled by

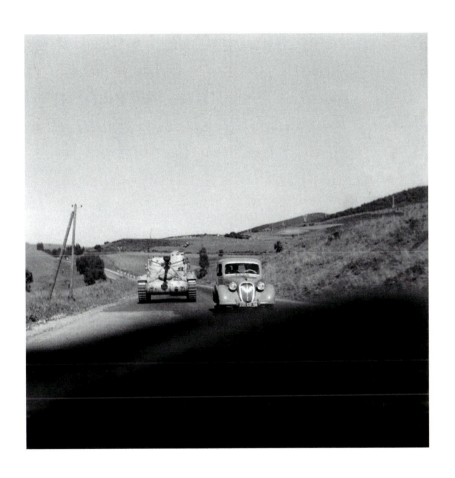

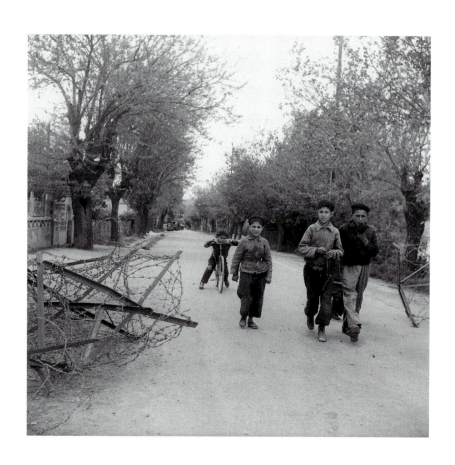

any concern about their future and, by the same token, unresponsive or (according to one's viewpoint) ungrateful to those "who have done so much for them."

There again, the war has changed many things. It has given this people, who had long been shunted off into the margins, a chance to appear (and not least to themselves) as adults, reflective and mature. It has also given them a chance to experience freely accepted discipline—in other words, autonomy. We know, for example, about the repudiation of wives in Algeria. And according to an official publication, "this is an area in which a degree of authority would be salutary, given that the Muslims do not, for the moment at least, seem very much inclined to give up the privilege in question."[3] But in various parts of Algeria, as it turned out, all that was required to bring about a significant decline in the number of repudiations was for the National Liberation Army (NLA) to issue precise directives. And in other ways too, it took the NLA just a matter of days to achieve results that a hundred and thirty years of "civilizing action" had not rendered possible. It has also been reported from across the country that disputes that had been dragging on interminably (with a degree of complicity on the part of the adversaries) have been settled by NLA combatants in a matter of minutes. And the free acceptance of discipline imposed on Algerians by Algerians in the common interest has put an end to many other forms of resistance that were previously seen as insurmountable.

But—and this is a very important fact—most of the forms of discipline thus imposed are, in fact, identical in every way to those that had been laid down by the French authorities. The NLA raises taxes, keeps official records, builds schools, etc. And in medicine, sanitation, the legal system, and the administration, the new norms are similar to those that apply in the West. By adopting institutions and techniques that, in the popular mind, appeared indissociable from those of the colonial system (and that, for this very reason, aroused ambivalent attitudes), along with regulations and directives that were similar in content and formulation to those dictated by the French authorities, the FLN would seem to have broken the nexus that intuitively

linked all these different institutions and techniques to the system of colonial domination. A change of sign has taken place.

In this new context, the relationship between the dominant caste and the subordinate caste has also been modified. The war has made it abundantly clear that a situation of dominance, like one of subordination, is capable of being called into question. The start of the conflict was also the start of decolonization.

The war, to begin with, was an adventure—or at least that is how it was perceived by Algerians in their daily lives, at the village level. With exchanges of information and experience, they gradually came to realize that the same kinds of event were occurring in many different places. The feeling of being involved in a common cause and a shared destiny, accompanied by that of having the same preoccupations and confronting the same adversaries, led to an expansion of the social space. The closed microcosm of the self-sufficient village opened up, and a feeling of solidarity began extending outward to the boundaries of Algeria itself. It is profound and is expressed in many different forms of behavior. Money-lending, for example, has practically died out, both because it is subject to broadly accepted sanctions and because, in keeping with the new spirit of the times, interest-free loans are now available. To call in a debt dating from before 1954 is considered dishonorable, and most disputes are settled by a mediator in the name of Algerian solidarity. "Fraternity" used to denote the fact of belonging, in real or fictive terms, to a given social unit (more or less extended), or a particular religion. Today the word tends to be synonymous with national solidarity and to have few specific ethnic or religious connotations.

Thus it is that the war, by its very existence and the kind of awareness it has generated, has brought about a genuine sociological transformation. And to this generalized phenomenon must be added the disruptions that are the direct, immediate results of the way it is being fought, among which one might point out, in order of importance, internal migration, whether free or forced; generalized insecurity; the different measures taken by the adminis-

tration and the army; and, finally, the considerable intensification of cultural contagion.

Algeria is undergoing a diaspora. Movements of population, whether voluntary or not, have taken on enormous proportions. According to the estimate, the number of displaced persons is between 1 million and 1.5 million, the latter figure being the more plausible. It may be stated, without risk of error, that as many as one in four Algerians now lives some distance from his or her habitual residence. Internal migration is in fact a complex phenomenon, and it takes highly diverse forms, of which resettlement is just one aspect. Villages whose inhabitants have gone to live in towns, for example, especially in Greater and Lesser Kabylia, are often taken over by people from even more troubled or impoverished regions.[4]

Internal migration also takes the form of population movements into the towns, which can seem to country people like a refuge from poverty and insecurity. "It's paradise here" is a refrain that is often heard in Algiers. "You're out of the storm." Those who work in France often arrange for their families to move to a town, or to stay with a brother or other relative, if they cannot bring them across to France. And they sometimes take a few days' leave to go back and take care of things themselves. But the slums are expanding ceaselessly, with the former inhabitants of the casbah, who have fled the endless routine checks and searches, being replaced by influxes of people from the country, living in appalling conditions.

Most of the resettlement centers, too, are little more than "cesspits of destitution," to quote an official report; or, if one prefers, *rural slums*. Again according to the report, just a third of them are viable. In such cases, the people have access to their own land, or to land that has been allotted to them. The problem of nutrition does not arise, and living conditions are reasonable. For the other two thirds, it may be supposed that there is a severe problem of food supplies, particularly in those centers (a third of the total) that were established as a result of operational imperatives and are "destined to disappear as soon as the security situation has returned to normal."

The mere fact of moving to a resettlement center, to a town, or to France can dramatically change people's attitudes. A new environment involves a break with tradition that generally culminates in the impossibility, whether it be viewed as temporary or permanent, of returning to one's customary place of residence. This can be seen in the analysis of a particular case—that of a woman aged around 60 who had lived in a town since the age of 14 but had never ceased to maintain close relations with her native village in Lesser Kabylia, where she spent several months each year. In 1955, the village became inaccessible. And it was only then that this woman's separation from family and tradition, which after some 50 years of life in a town had still not become totally definitive, led to a real change in her attitudes, particularly with regard to Western ways. Whereas she had hitherto been content to do the heavy work and had shunned European techniques, she now started ironing and knitting. She would never before have eaten food she was not familiar

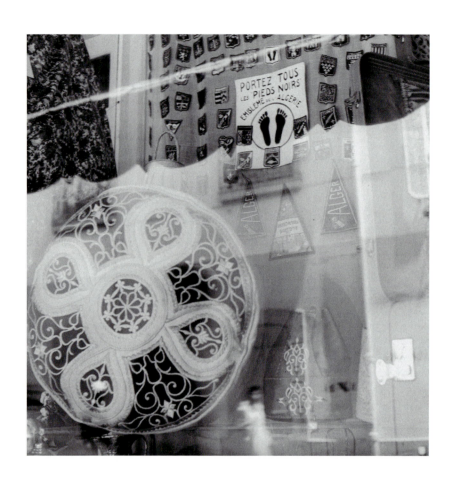

PORTEZ TOUS
LES PIEDS NOIRS
EMBLEME DE L'ALGERIE

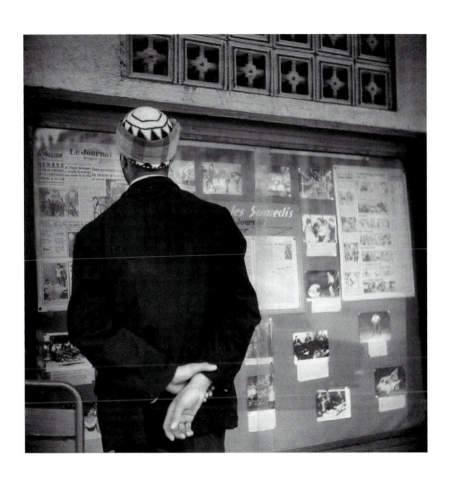

with. She had never listened to the radio, nor had she taken the slightest interest in politics. In sum, it was as though the fact of becoming aware of the break (more than the break itself) made her feel a need to adapt to a new world that up to then had remained alien to her.

"Community" man is giving way to "herd" man who has been deprived of the organic and spiritual realities in and through which he had previously existed. Cut off from his social and geographical origins, his circumstances are often such that he cannot recall even the most ancient ideals of honor and dignity. The war and its aftermath, resettlements and rural exodus, have simply reinforced and accelerated the tendency to cultural disintegration that had been set in motion by contact with "civilization" and the colonial situation. And the movement is now extending to areas that had previously been spared because they had not been directly targeted by the colonialist enterprise, but also because they consisted of small, close-knit rural communities, obstinately faithful to their past and their traditions, which had been able to preserve the essential traits of a civilization that may now be spoken of only in the past tense. A network of small, highly structured communities has given way to a congeries of individuals without attachments or certainties.

Time-honored values of honor have crumbled on contact with the brutalities and atrocities of war. As one old Kabyle said, "There isn't a man who, at the end of all this, will be able to say, 'I'm a man.'" The ideal image of the self, and the values associated with it, are put to the cruelest of tests. Women are raped and abducted. Husbands are interrogated and beaten up in front of their wives. I have been told about a village in Greater Kabylia where soldiers accompanied the women to the fountain just outside the settlement, for their protection. On their return, some of the women drank coffee with the soldiers, or even invited them into their houses. "The young soldier enters the house. The old man, the defender of honor, who has been charged with watching over the wife or the daughter of an exile, knows he can say nothing. He suffers, and remains silent in his corner. One day, the soldier brings food. The old man accepts his share, and is silent. He is ruined."

The war, like a bomb, devastates sociological realities. It crushes, grinds down, and disperses traditional communities—village, clan, family. Thousands of men are in hiding, in internment camps or in prison, or have taken refuge in Tunisia or Morocco. Some are living in towns, in Algeria or France, having left their families behind in their villages, or in resettlement centers. Others are in the French army. Still others are dead, or have simply disappeared. Families have been dismembered and scattered to the four winds. Entire regions, in Kabylia, for example, have been emptied of their menfolk. For the last few months, the clinic run by nuns near Chabet El Ameur has seen no births.

A change is taking place, as a result, in the relations between the sexes. Many women, and not just the widows, have assumed those duties and tasks that had previously been incumbent on their husbands. They often have to support their families, even if they are receiving help from a brother or an uncle. Their vital space, which had been extremely restricted, is expanding. They enjoy the freedom of European towns, go to the shops, take a train to visit a husband or a brother, deal with the authorities. They have made the transition from their cloistered, secret universe to domains that had previously been reserved for men. Involved in the war either directly or indirectly, as participants or victims, and forced to take on new roles, Algerian women, whether married or not, have acquired greater freedom in recent years. The fragmentation of the family unit has led to its members becoming aware of their individual personalities, but also their responsibilities. In the towns, the young people no longer bow to the traditional control mechanisms that provided the sempiternal pillars of order in village communities. The absence of a father can signify disorientation; and many young men, especially in the towns, are now in the position of what the Kabyles call "the widow's son," even though their fathers may actually still be alive. Bereft of a past, a tradition, an ideal of the self, they are left to their own devices. Paternal authority, though still very much alive, has been undermined. It is no longer seen as the foundation of all values and a touchstone in every issue. Most young men

and women have adopted a new system of values, in the light of which traditions can be called into question. And this is especially true of the fifteen-to twenty-year-olds, whose character has been shaped by the war. With their adolescent radicalism, looking to the future and knowing nothing about the past in which, for better or worse, the older people are rooted, many of them are driven by a spirit of revolt and negativism. And the psychological schism between the generations is often further widened by enforced separation. The perpetuation of tradition presupposes continuous contact between generations, and a respect for the elders, whose influence, in village communities, can extend well beyond childhood. Adults, in fact, continue to recognize the authority of their fathers as long as they live nearby. With the dispersion of families, it is the continuity of tradition that is fundamentally compromised.

Thus it can be said that, along with influences such as that of education (which has added to the pressure exerted by the young people, with their desire for emancipation, and the cultural contagion that has tended to create oppositions between the lifestyles and values of the different generations), the war has overturned the system of relationships that formerly characterized the Algerian family, which is in danger of disintegrating if it cannot find a new equilibrium. Algerian society has been shaken to its very roots, radically and brutally.

"We're living in the 14th century . . ."—the century of the end of the world, where everything that had been the rule is now the exception, and everything that had been forbidden is now permitted. Children no longer respect their parents, women go alone to the market, and so on. Popular consciousness sees an upside-down universe. The surrounding disorder and chaos look like the world of an end, foreshadowing the end of a world. And in Algeria we are indeed looking at the end of a world; but the end of this world can also be seen as the beginning of a new world.

Algerian society is undergoing a complete upheaval. And no part of it is spared. The pillars of the traditional order have been weakened, or indeed demolished, by the colonial situation and the war. The urban middle class has been torn apart, and the values it embodied have been supplanted by new ide-

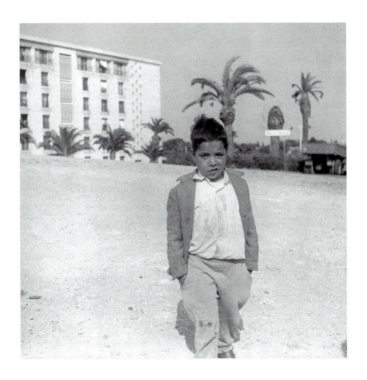

ologies. Most of the feudal chiefs, compromised by their support for the colonial administration, and thus, in the people's eyes, associated with a system of oppression, have lost their temporal power and spiritual authority. The rural masses, obstinately conservative in their rejection of every innovation proposed by the West, are being swept up in the whirlwind of violence that is in the process of obliterating the past. Even Islam, having been mobilized (more or less consciously) as a revolutionary ideology, has progressively changed its function and signification. The nature, duration, and amplitude of the war have spawned a radical revolution. And it may be supposed that the return of peace will usher in a very different Algeria from the one in which the war began—an Algeria that will be profoundly revolutionary, because it will have been profoundly revolutionized.

To analyze the consequences of the war in sociological terms does not simply mean painting a picture of ruins and rubble. The current radical transformation is not something categorically, exclusively negative. The facts point, indeed, to the advent of a new politics whereby this catastrophic experience of social surgery could be turned to advantage. It would appear that Algeria is a country where, contrary to what has often been claimed, everything remains possible, if the masses that have been brought into being by the colonial situation and the war through the destruction of communities are allowed to fulfill their destiny in a spirit of freedom and responsibility. An aggregate of disoriented, tormented atoms may then give way to a new form of social unity, not founded on organic adhesion to the values of an age-old tradition but on active, creative, purposeful participation in a common enterprise.

Études méditerranéennes, 1960, pp. 25–37

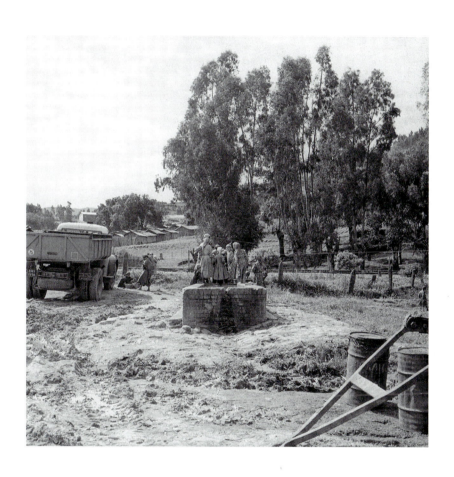

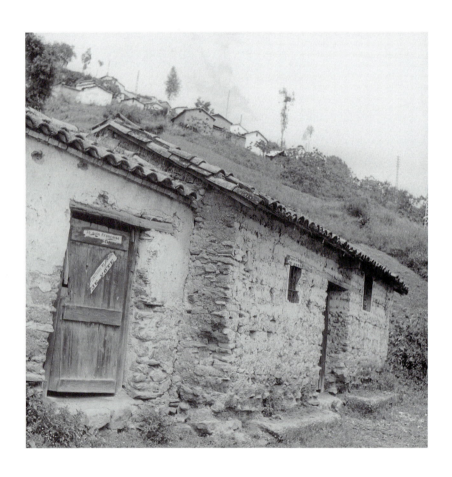

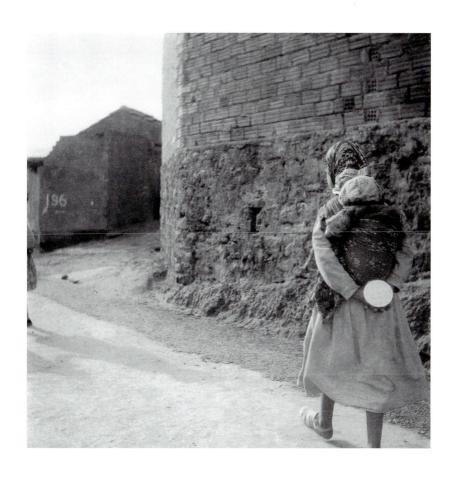

HABITUS AND HABITAT

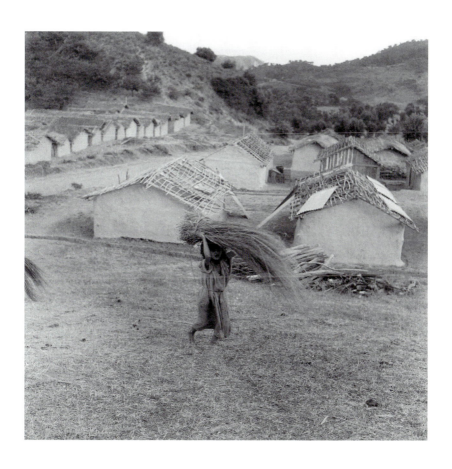

The main thing is, in fact, to group together these people, who are every-
where and nowhere. The main thing is for us to achieve some control over
them. When we have them in our power, we will be able to do many things
which are currently impossible, and which may allow us to take hold of
their minds, after having taken hold of their bodies.

Captain Charles Richard, *Étude sur l'insurrection du Dahra* (1845–1846)

I'm from Lorraine, and I like straight lines. The people here have difficulties
with straight lines.

Lieutenant, Kerkera, 1960, *Le Déracinement*, p. 19

War and persecution have finished off what had been started by colonial
policy and the generalization of monetary exchanges. The most seriously af-
fected regions are those that had previously been more or less untouched by
colonialist enterprises. It was in these mountainous regions that small rural
communities, closed in upon themselves in obstinate fidelity to their tradi-
tions, were able to preserve the essential features of a culture that can now be
spoken of only in the past tense. This was the case for the Kabylias, Aures and
Nemenchas, Bibans, Hodna, Mitidjien Atlas, Titteri, and Ouarsenis, where
traditional culture remained relatively unchanged, in spite of the internments
that followed the insurrections, along with the creation of new administra-
tive units and many other measures, and also in spite of the transformations
brought about by cultural contagion. By 1960, the border zones and moun-
tainous areas where the National Liberation Army was able to establish its
presence with the greatest rapidity and effectiveness had been almost entirely
emptied of their inhabitants, who were resettled in the plains or went to the
towns.

It was as if this war had provided an opportunity to push to its conclusion
the latent intention of colonial policy, which was profoundly contradictory:
disintegration or integration; disintegration for the purpose of integration,

or integration for the purpose of disintegration. Colonial policy always vacillated between these mutually contradictory options, and no clear plan was systematically applied, so that contradictory views could be held by different officials at the same time, or the same official at different times. A desire to destroy the structures of Algerian society could in fact derive from two opposing ideologies. One of these was dominated exclusively by the interests of the colonizer and was concerned with strategy, tactics, or proselytizing. It was often tinged with cynicism. The other was assimilationist or integrationist and was generous only in appearance.

Le Déracinement, p. 23

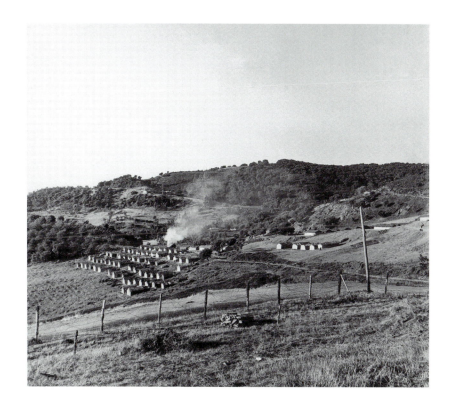

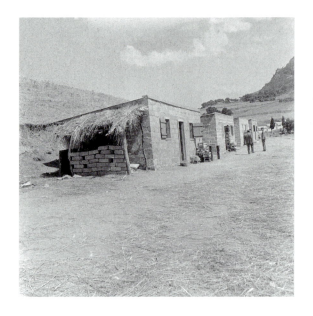

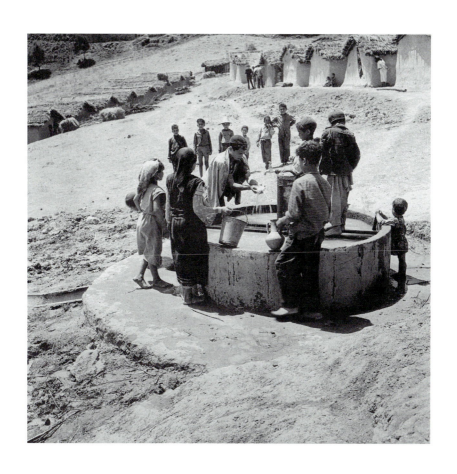

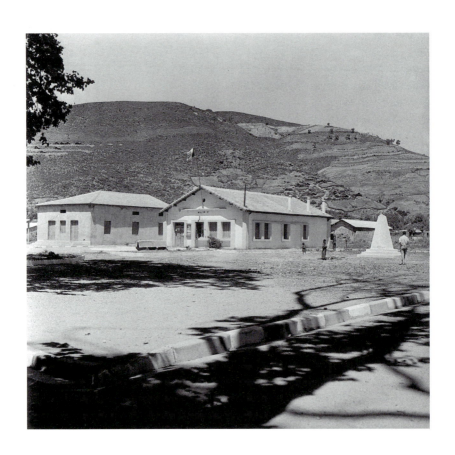

Systematically imposing a uniform type of organization on the habitat, including those regions that, being the most inaccessible, were also the most favorable to the prosecution of a revolutionary war, the resettlement program moved Algerian society in the direction of homogenization. But the transformations of the economic and social order have been as much a result of the ecological, economic, social, and cultural characteristics of the disrupted social groups as of the form and intensity of the disruptive action. Which means that in order to fully understand the meaning and scope of this action, it must be realized that differences between ethnic groups and cultural traditions have increased over the colonial period.

Le Déracinement, p. 29

Like the Roman colonizers, the officers who were given responsibility for setting up local organizations began by imposing order on the space itself, as though they hoped in this way to impose order on the people. The key notions were uniformity and alignment. Houses were constructed according to stipulated norms, in stipulated locations, along wide streets, following the example of a Roman camp or a colonial settlement. In the middle was the main square, with the triad typical of a French village: town hall, school, war memorial. And it might be supposed that if they had had the time and the means, the officials of the Sections Administratives Spécialisées (SAS), with their penchant for geometry, would have done the same with the land. In their ignorance of social realities, whether conscious or not, the authorities generally imposed on the "resettled" groups a type of order that was in no way suited to them, any more than they were suited to it. With a sense of implementing a grand design, namely, "the evolution of the masses," and a passion for innovation and regulation, they poured all their enthusiasm and energy into this work. Uncompromisingly, and unwittingly, they constructed the kinds of organizational schema that might typify, in essence, any enterprise of total, systematic domination. It was as if the colonizer were instinctively reverting to the ethnological law that the reorganization of a habitat, as a

symbolic projection of fundamental structures, can bring about a generalized transformation of the cultural system.

Le Déracinement, p. 26

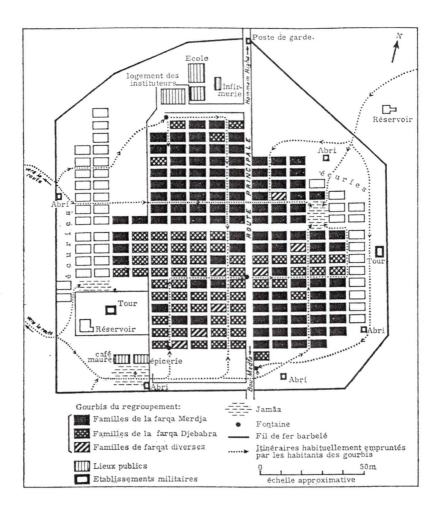

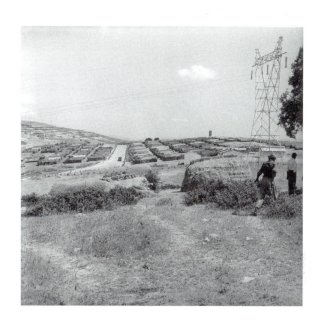

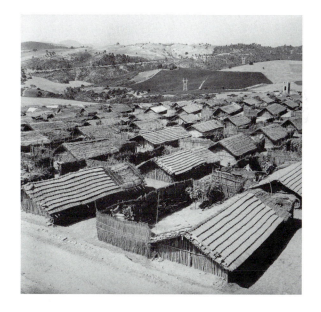

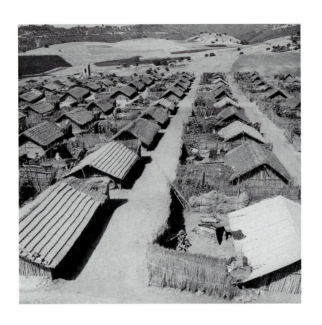

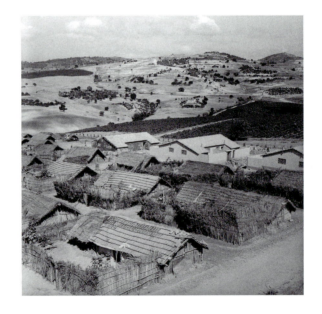

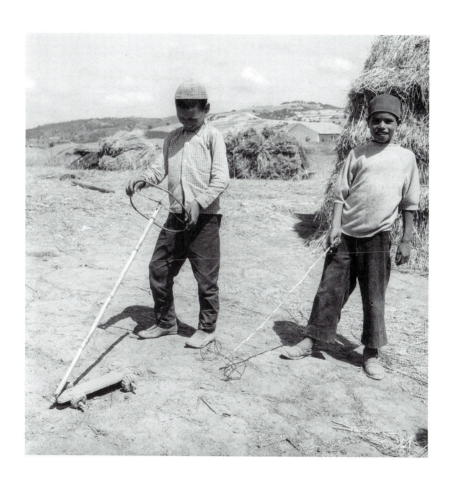

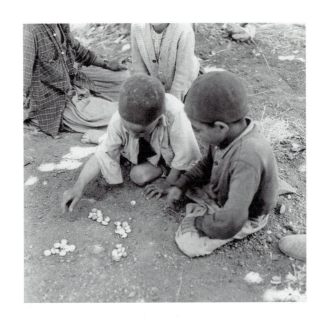

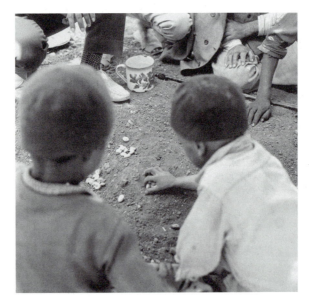

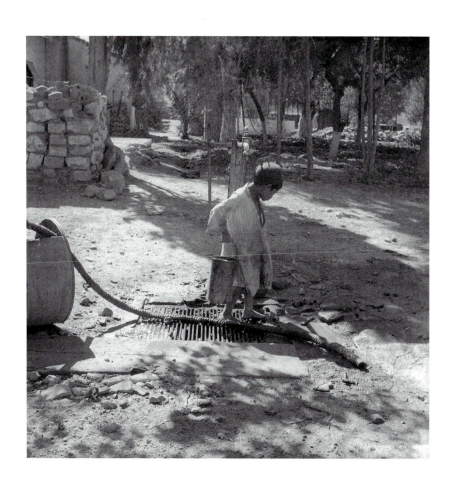

There is nothing surprising about the constancies and recurrences of colonial policy. After a century, apart from some superficial differences, the same methods are still being used. The resettlement policy, as a pathological response to the fatal crisis of the colonial system, has revealed its pathological intention.

Le Déracinement, p. 27

Farmers have been forced out of their customary residences and into large resettlement centers whose locations are often chosen for purely military reasons. And we are well aware of the appalling material and psychological conditions that prevail in those of Tamalous, Oum Toub, and Bessombourg in the Collo region. Nothing could be less well planned or methodical. It would be futile to look for order in the whirlwind of anarchic displacements that has accompanied the repression.

Le Déracinement, p. 12

The "resettled" people have been placed in a position of absolute dependence on the SAS, who, under the pressure of events they themselves brought about, have had to accept responsibility for those who, up to then, they had intended simply to neutralize and control. This led to the "relaxation," and the "desettlement." So it was actually quite late in the day that resettlement changed from a consequence of evacuation to an actual objective, and even, progressively, the cornerstone of a systematic policy. In spite of a prohibition, proclaimed at the start of 1959, against displacing people without the authorization of the political authorities, the resettlements continue apace. By 1960, the number of resettled Algerians had reached 2.157 million, in other words a quarter of the total population. And if one also takes into account the exodus toward the towns, it may be estimated that in 1960 at least 3 million people, or half the rural population, were living some distance from their customary residences. This population displacement has been among the most brutal in human history.

Le Déracinement, p. 13

automne → hivане - hivане → automne

labour
laboureur chaussé de cuir de boeuf.

soc = fécondité
~~joignit à ~~ yer
~~fraiche~~
~~joie~~
~~humide~~
germination - formation des épis
~~fécondité~~ ~~~~

debbah : le sacrificateur.
le jour de la 1ère neige, il passe dans les maisons très
tôt pour annoncer la neige et il demande aux gens
s'ils veulent sacrifier une poule - Il fait l'égorgement -
et le soir il vient chercher une cuisse.
On peut remplacer soit par kilos de viande ou par $fleur$ -

moisson
~~moiss~~ ~~~~ tablier f. de haine
~~les fleurs~~
~~faucille : castration~~

~~mai à battre~~
~~batt fenêtres~~
~~sèche~~
~~des moulins~~ ~~~~

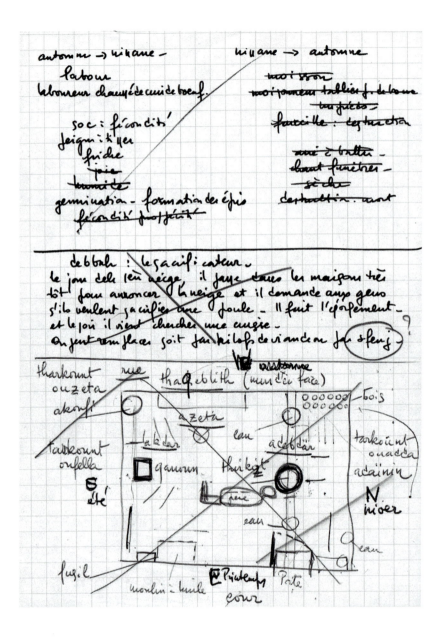

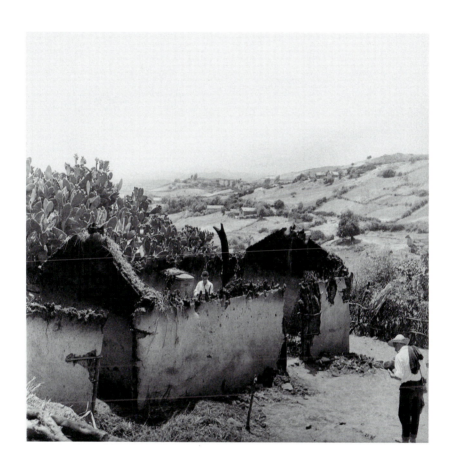

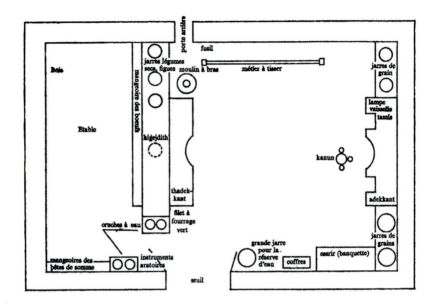

I would never have come to study ritual traditions if the same concern to "rehabilitate" which had first led me to exclude ritual from the universe of legitimate objects and to distrust all works which made room for it had not persuaded me, from 1958, to try to retrieve it from the false solicitude of primitivism and to challenge the racist contempt which, through the self-contempt it induces on its victims, helps to deny them knowledge and recognition of their own tradition. For, however great the effect of respectability and encouragement that can be induced, unconsciously rather than consciously, by the fact that a problem or a method comes to be constituted as highly legitimate in the scientific field, this could not completely obscure for me the incongruity and even absurdity of a study of ritual practices conducted in the tragic circumstances of war. This was brought home to me again recently when I rediscovered some photographs of stone jars, decorated with snakes and intended to store seed corn; I took those photographs in the course of fieldwork in the Collo region, and their high quality, although I had no flash-

gun, was due to the fact that the roof of the house into which these fixed furnishings had been built had been destroyed when the occupants were expelled by the French army. There was no need to have exceptional epistemological lucidity or outstanding ethical or political vigilance in order to question the deep-rooted determinants of a so obviously "misplaced" *libido sciendi*.

The Logic of Practice, p. 3

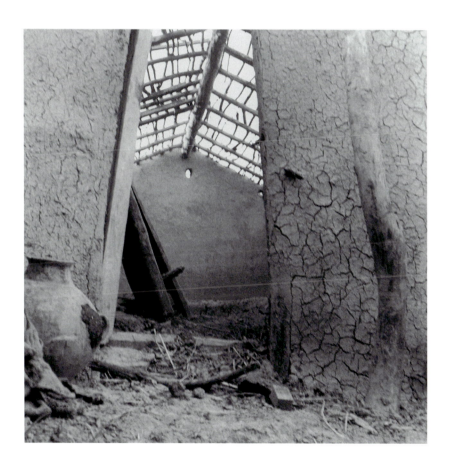

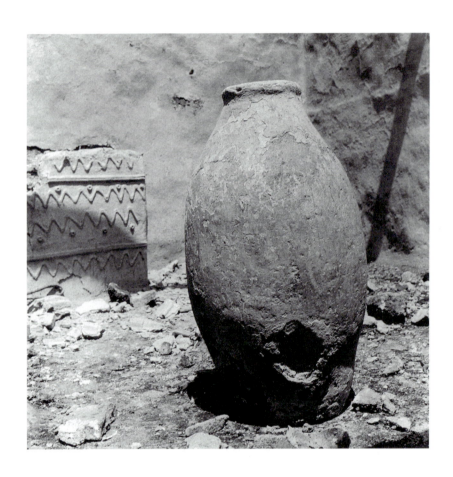

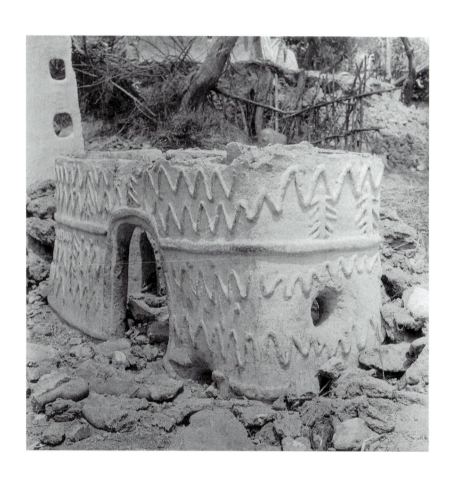

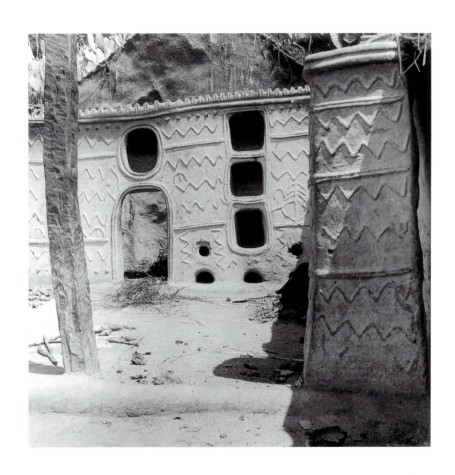

The Kabyles keep their wheat and barley in large earthenware jars made with holes at various heights, and the prudent mistress of the house, responsible for managing the reserves, knows that when the level of the grain falls below the central hole, called *thimith*, the navel, she must curb consumption. The "calculation" is automatic and the jar functions like an hourglass showing at all times how much has gone and how much is left.

Algeria 1960, p. 12

MEN–WOMEN

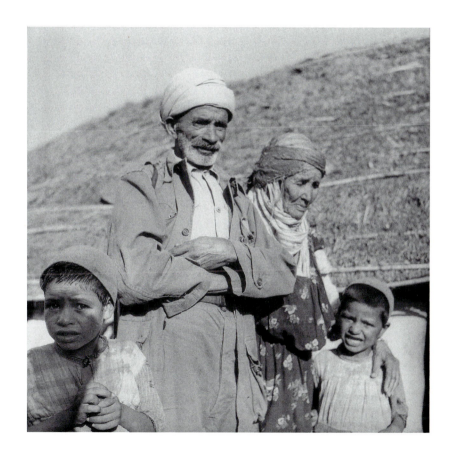

Bodily *hexis* is political mythology realized, *embodied*, turned into a permanent disposition, a durable way of standing, speaking, walking, and thereby of feeling and thinking. The opposition between male and female is realized in posture, in the gestures and the movements of the body, in the form of the opposition between the straight and the bent, between firmness, uprightness, and directness (a man faces forward, looking and striking directly at his adversary), and the restraint, reserve, and flexibility. As is shown by the fact that most of the words that refer to bodily postures evoke virtues and states of mind, these two relations to the body are charged with two relations to other people, time and the world, and through these, to two systems of values. "The Kabyle is like the heather, he would rather break than bend." The man of honor walks at a steady, determined pace. His walk, that of a man who knows where he is going and knows he will get there on time, whatever the obstacles, expresses strength and resolution, as opposed to the hesitant gait (*thikli thamahmahth*) announcing indecision, halfhearted promises (*awal amahmah*), the fear of commitments and inability to fulfill them. It is a measured pace, contrasting as much with the haste of a man who "walks with great strides," like a "dancer," as with the sluggishness of a man who "trails along."

The same oppositions reappear in ways of eating. First, in the use of the mouth: A man should eat with his whole mouth, wholeheartedly, and not, like women, just with the lips, that is, halfheartedly, with reservation and restraint, but also with dissimulation, hypocritically (all the dominated "virtues" are ambiguous, like the very words that designate them; both can always turn to evil). Then in rhythm: A man of honor must eat neither too quickly, with greed or gluttony, nor too slowly—either way is a concession to nature.

The manly man who goes straight to his target, without detours, is also a man who refuses twisted and devious looks, words, gestures, and blows. He stands up straight and looks straight into the face of the person he approaches or wishes to welcome. Ever on the alert, because ever threatened, he misses nothing of what happens around him. A gaze that is up in the

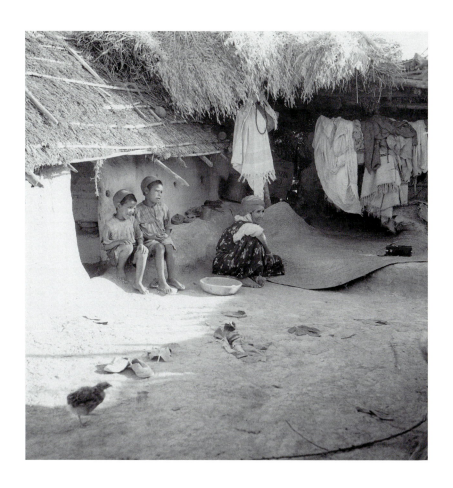

clouds or fixed on the ground is that of an irresponsible man, who has nothing to fear because he has no responsibilities in his group. Conversely, a well-brought-up woman, who will do nothing indecorous "with her head, her hands or her feet" is expected to walk with a slight stoop, avoiding every misplaced movement of her body, her head, or her arms, looking down, keeping her eyes on the spot where she will next put her foot, especially if she happens to have to walk past the men's assembly. She must avoid the excessive swing

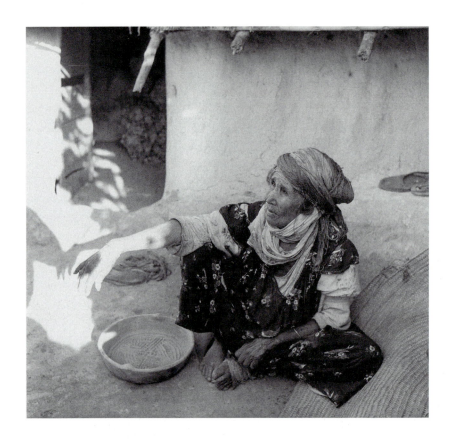

of the hips that comes from a heavy stride; she must always be girdled with the *thimeh'remth*, a rectangular piece of cloth with yellow, red, and black stripes worn over her dress, and take care that her headscarf does not come unknotted, uncovering her hair. In short, the specifically feminine virtue, *lah'ia*, modesty, restraint, reserve, orients the whole female body downwards, towards the ground, the inside, the house, whereas male excellence, *nif*, is asserted in movement upwards, outwards, towards other men.

The Logic of Practice, pp. 69–70

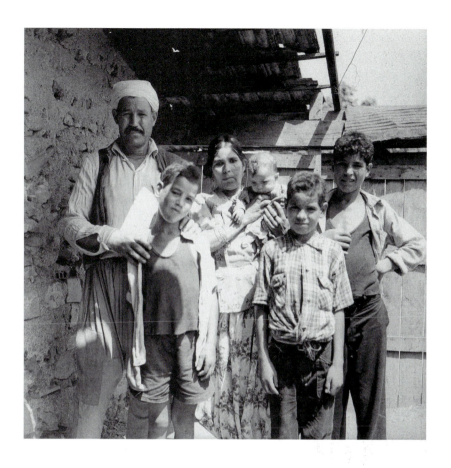

The divisions constitutive of the social order, and, more precisely, the social relations of domination and exploitation that are instituted between the sexes thus progressively embed themselves in two different classes of habitus, in the form of opposed and complementary bodily *hexis* and principles of vision and division which lead to the classifying of all the things of the world and all practices according to distinctions that are reducible to the male/female opposition. It falls to men, who belong on the side of all things external, official, public, straight, high, and discontinuous, to perform all the brief, dangerous,

and spectacular acts which, like the sacrifice of the ox, plowing, or harvest-
ing, not to mention murder or war, mark breaks in the ordinary course of life;
women, by contrast, being on the side of things that are internal, damp, low,
curved, and continuous, are assigned all domestic labor, in other words the
tasks that are private and hidden, even invisible or shameful, such as the care
of the children or the animals, as well as the external tasks that are attrib-
uted to them by mythic reason, that is to say, those that involve water, grass,
and other green vegetation (such as hoeing and gardening), milk and wood,
and especially the dirtiest, most monotonous and menial tasks. Because the
whole of the finite world in which they are confined—the space of the village,
the house, language, tools—contains the same silent calls to order, women

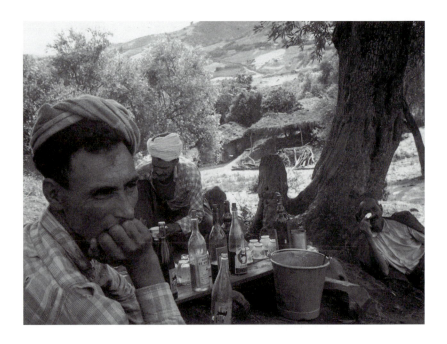

can only *become what they are* according to mythic reason, thus confirming, and first in their own eyes, that they are naturally consigned to what is low, twisted, picayune, futile, menial, etc. They are condemned to give at every moment the appearances of a natural foundation to the diminished identity that is socially bestowed on them: They are the ones who perform the long, thankless, tedious task of picking up from the ground the olives or twigs that the men have brought down with a pole or an axe; they are the ones who, delegated to the vulgar preoccupations of the everyday management of the domestic economy, seem to take pleasure in the petty calculations of debt and interest to which the man of honor does not stoop.

Masculine Domination, p. 30

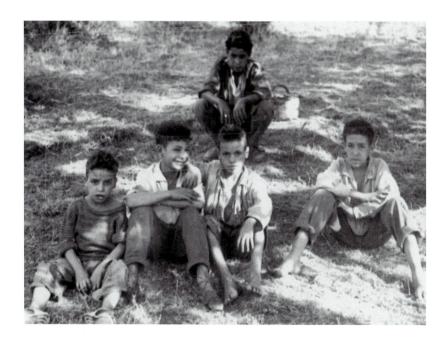

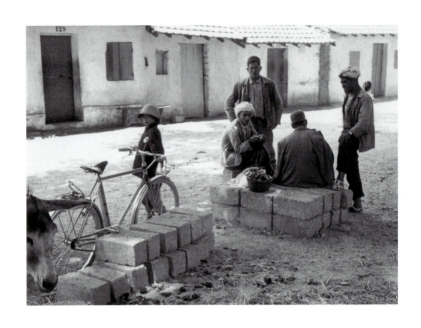

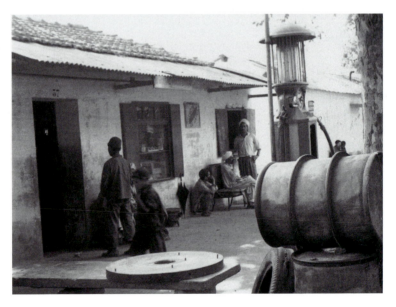

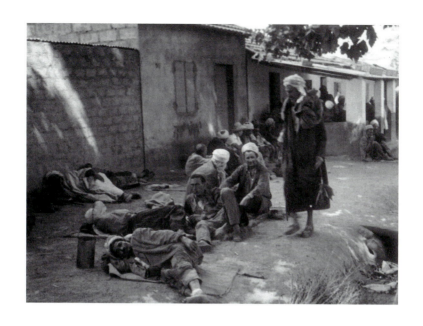

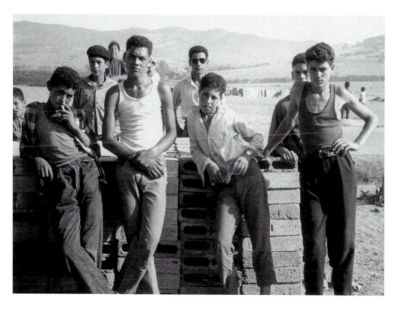

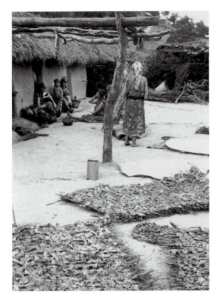
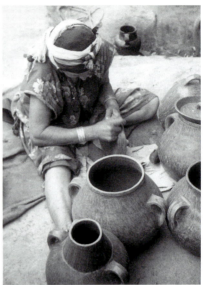
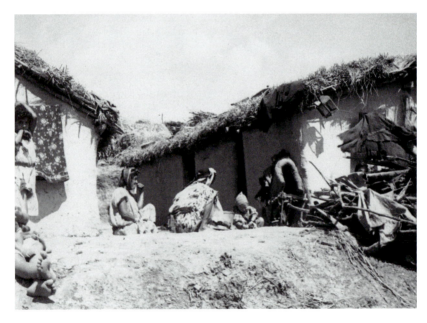

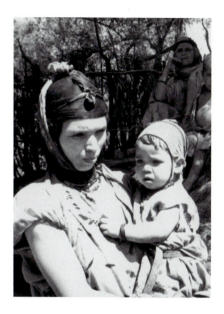

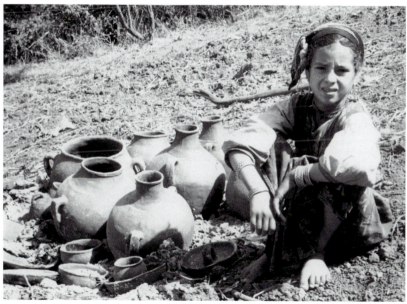

garçon se définit par opposition à "garçon des filles" —
combattif — "méchant des autres" "mais qu'emmerde" (fils de la...)
pères et ... ne jouent pas ensemble — jeux entre
garçons et entre filles.

jeux : dans ... des clans entre villages —
on joue le jeu du conflit entre villages. Autrefois gens
mariés jouaient encore.

Travaux masculins — travaux féminins

	Hommes	Femmes
intérieur		cuisine
	feu de veillée (st veillée entre h.)	feu de cuisine
	café (recirculation luxe des hommes)	
	sert le café	
	coupe le bois débite le bois (s'il y a pas... que, d'ailleurs il est une)	ramasser du bois. découper les brindilles.
	tabou du balai	balayage. f. balaie l'aire à battre
aiguille = masculin	h. fent ... (autref. d'h. seul savait) c'est l'h. qui cousait rôle de sa f. — Mnt coud son propre linge	
	direction de l'h.	veille ... réparer

Homme	Femme	6

nourrit les animaux (je leur
donne je leur donner)
abreuve les anim.
non traire

trait les animaux

accompagne le vieux - troupeau

{ 1 ou 2 bêtes au ~~champs~~ jardin
{ et un enfant -

tabou.

entretien des enfants
toilette

tabou
porte le fumier au champ.
(à dos de bête)

porte le fumier au jardin -
(sur dos) -

gaulage

tabou du gaulage
~~cueillette~~ ramassage - cueillette

moisson

tabou (sauf cert. régions :
Beni Oughlis - mais c'est senti
cme aberrant) -

glanage

Everywhere in the country it is the women who have suffered most from the resettlement process. They spend their days confined to stifling shacks. It is the men or the children who go out for food and water. In Kerkera, the men fetch water in buckets, or in barrels carried by donkeys, or sometimes in jars that the women leave at the corner of their houses, and then collect when they have been filled, without ever crossing the street. But down the hill from the resettlement center, and at a certain distance from the main thoroughfare, out of sight of the men and accessible only by a roundabout path, the traditional Ain Boumaala fountain, which supplies the needs of Zriba, is available to the women, and it is there that they wash their clothes, blankets, and sheepskins. A number of them also take water from there, despite the closer proximity of new springs, because it is a place where they can talk for a while. In Djebabra, nostalgia for lost homes and the social life of former times is expressed differently: Groups of women spend their afternoons in their former homes, between a quarter and half an hour's walk away. Such pitiable attempts to perpetuate the old way of life indicate the disarray they feel in the resettlement centers. And these specific, direct influences, added to the general conditions of economic and social life, give a sense of the transformation that has taken place in the role traditionally allotted to women by the social group.

Le Déracinement, p. 134

Resettlement prevents the women from performing most of their traditional tasks. It is on them that the interventionism has been focused, because the authorities, like most other naive observers, see the condition of the Algerian woman as the most blatant sign of the "barbarism" they want to eradicate by every possible means, direct or indirect. On the one hand, the military have created women's groups and workplaces; on the other hand, they are trying to destroy everything that looks to them like an obstacle to "the liberation of women." In Kerkera, as in many other centers, the houses have had their courtyards taken away. Fountains and washhouses are everywhere located in

the center of the village. And more generally, military action and repressive measures are targeted at the morality of honor that governs the division of labor and the relations between the sexes.

"Paysans déracinés, bouleversements morphologiques et changements culturels en Algérie," p. 72

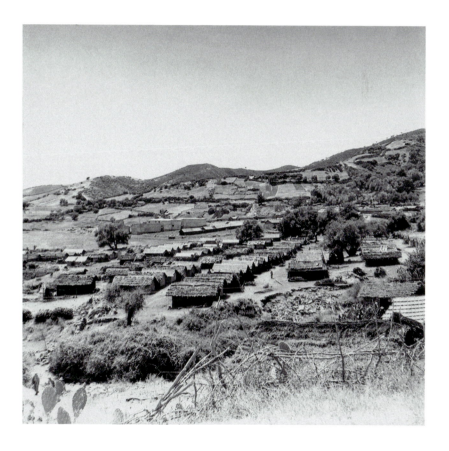

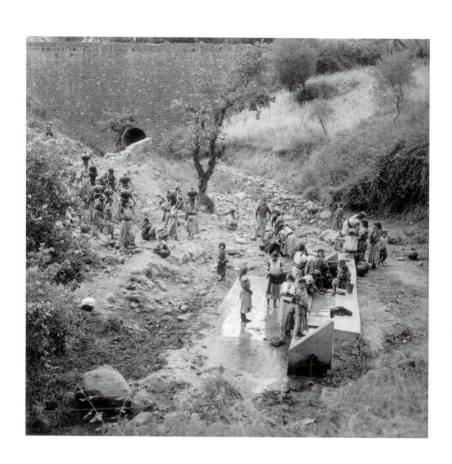

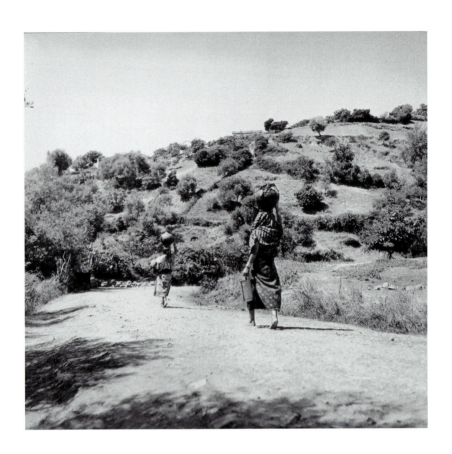

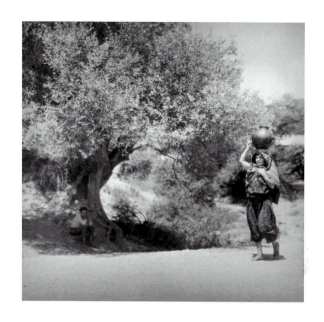

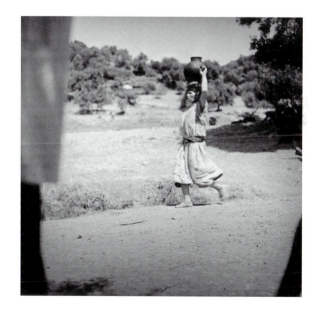

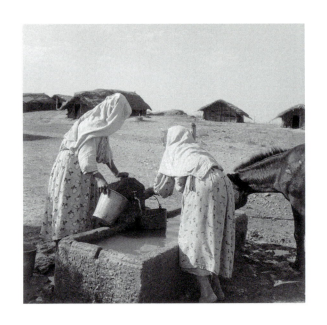

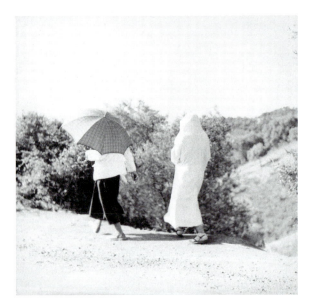

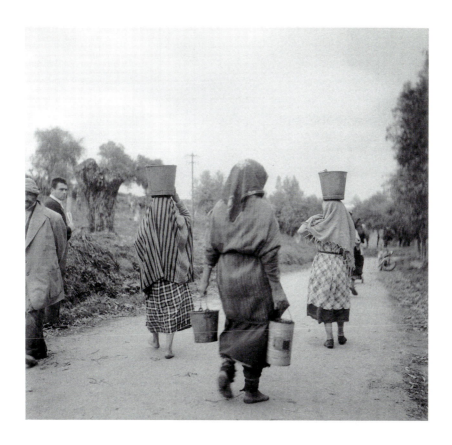

In the first place, the measures taken by the authorities, along with the simple fact of contact between different groups over recent history, and the phenomenon of acculturation, have speeded up the process of cultural change. Official policy has been inspired by an intention, implicit or explicit, that the Algerian population should "evolve" toward Western social structures and attitudes. Clan or family unity, with its genealogical basis, is to be replaced by village unity, on a spatial basis. And extended families comprising several generations living together are to be replaced by Western-style households. In a number of places, the "resettled" people have been forced to build as

many houses as there are families. Some have also had to build houses for relatives who emigrated, and there have been cases of emigrants themselves returning for this purpose. The separation of habitats has accentuated and accelerated the breakdown of bonds: Each family now has its own cooking pot and budget, just as most of them already had their own land. The arrival of other groups, the fragmentation of communities, the corrosive influence of shantytown life and the precariousness of the habitat are also weakening customary ties, while at the same time generating solidarities of a new type, based on proximity and, especially, similar living conditions.

Le Déracinement, pp. 118–119

In addition to the increased autonomy of the couple, which tends to become an independent economic unit and even to break away whenever its resources permit, the change in the structure of the activities of the different members of the family produces a certain number of important transformations. First, even when urbanization brings about emancipation in other areas, the wife's economic dependence increases, especially since even partial or unconscious adoption of capitalist economic dispositions leads people to disparage female activities by acknowledging as real work only that which brings in a money income. Unable to take outside work, the wife is assigned to the home and is completely excluded (except in the most privileged strata) from the important economic decisions, sometimes not even knowing how much her husband earns. So long as the ideology which could justify and valorize her new function remains unformed, she finds herself relegated to an inferior rank and role more brutally and more totally than before, because the new economic and social universe tends to dispossess her even from the functions which the old society acknowledged to be hers.

On the other hand, though underemployment tends to have the opposite effect, young people's dependency on their parents decreases as soon as they start earning money, and particularly given the fact that, being better educated than their elders, they are more at ease in the economic world. Whereas it was traditionally the case that they remained under their father's authority

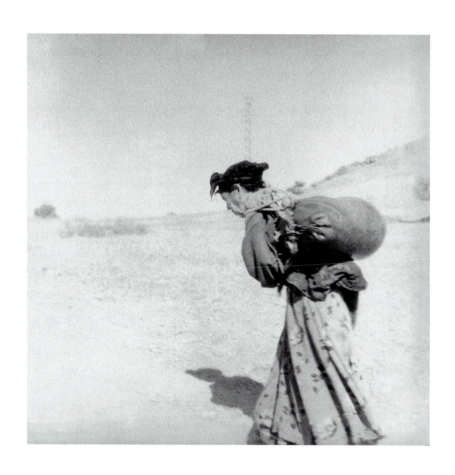

as long as he was alive, urban society can now provide them with the economic prerequisites of emancipation. As contributors to the family's income, they want to participate in the management of its budget, even if they continue, as is often the case, to hand over all or part of their salary to their father. There is not a family that has been spared a conflict of civilizations.

Algeria 1960, p. 47

Another sign of transformation in social relations has been the appearance of the veil. In rural society, previously, those women who were not bound to conceal themselves from the other members of their clan went to the fountain, and in the second place to the fields, by roundabout ways and at traditionally set times. Thus safe from prying eyes, they did not need to wear a veil, and they were not subject to *al-h'ujba*, the cloistered existence. But in the resettlement centers, as in the towns, it is not possible for each social unit to have its own space, and there is some overlap between that of the men and that of the women. With the total or partial cessation of agricultural work, the men spend their time in the village or their homes, and the women cannot continue to go about as freely as before without bringing shame and dishonor on the family. The rural woman who has moved to a town cannot adopt the townswoman's veil without denying her own identity, the result being that she must avoid appearing even on her doorstep. By creating a social domain of an urban type, resettlement has led to the introduction of the veil, so that women can move around among strangers.

There is a new function that has been added, like a graft, to the traditional function of the veil, by reference to the colonial context. Without pushing the analysis too far, it can be seen that the veil is primarily a defense of privacy and a protection against intrusion. And the Europeans have always, however dimly, recognized it as such. The veil allows Algerian women to create a situation of imbalance. It is like a form of cheating—they can see without being seen; without making themselves visible. And it is the entire subordinate society that, with the veil, rejects reciprocity. It scrutinizes, observes, and penetrates without being scrutinized, observed, or penetrated.

Le Déracinement, p. 70

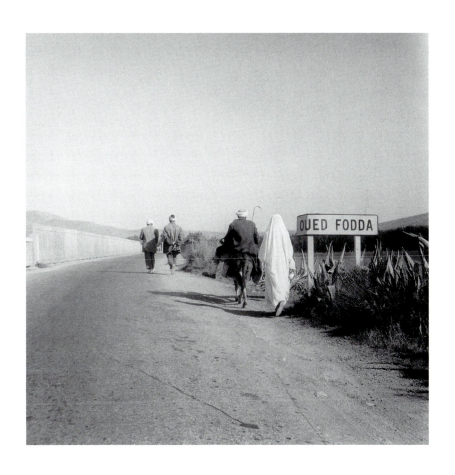

AN AGRARIAN SOCIETY IN CRISIS

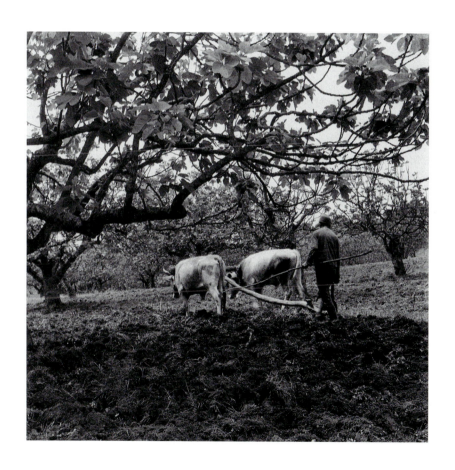

The day "Good evening" was revealed to us,
We took a mighty punch on the jaw:
We've had our fill of lockup jails.

The day "Good day" was revealed to us,
We took a hefty punch on the nose:
Blessings came to an end for us.

The day "Thank you" was revealed to us,
We took a serious punch on the throat:
The ewe inspires more fear than us.

The day "pig" was revealed to us,
A dog was worth more than us, for honor,
The *khammes* bought himself a mule.

The day "brother" was revealed to us,
We took a powerful punch on the knee:
We walk in shame, up to our chests.

The day "the Devil" was revealed to us,
We took a punch that made us you,
We became manure carriers.

<div align="right">

Hanoteau, Popular Poetry of Kabylia
from Djurdjura, 1862; *Le Déracinement*, p. 117

</div>

There is no more dishonor (*'aib*). There is no more fear of deserting one's land, or selling it to strangers. There is no more shame in abandoning one's father or mother to poverty. One does not hesitate to adopt any expedient, any trickery, for the purpose of earning one's living. To say that there is no more dishonor, signifying that there is no more honor, or point of honor, is to recall that honor, like dishonor, is experienced only before the court of opinion, before the group, unquestioning of its norms and values. In sum, the crisis in the value system is a direct consequence of the crisis that affects the group, which is the guardian of values. With the dispersal of social units, the undoing of traditional social bonds, and the weakening of control over opinion, transgressions of the rule are becoming generalized. There is no remaining obstacle to the individualism that has come in with the modern economy. The resettlement centers are sprawling, disparate aggregates of isolated individuals protected by their anonymity. Each one feels responsible for himself, but only for himself, and before himself. "In these times, everyone looks after himself. Each individual has only his wits to rely on. Each individual has to 'swim his sea' and count on 'his own knees' to earn a living. There's no more 'my uncle' or 'my brother.' Now people say 'each for his own belly,' 'every man for himself,' whereas before it was 'every man his grave,' because it's only there (in the afterlife) that each individual's confronted with his actions. On that day, I won't be able to do anything for you, and you won't be able to do anything for me, whereas life is only possible if there's mutual support. Who, especially these days, can boast of not needing anybody? As they say, "a man (is a man) through others" (*rajal berjal*). Whether it be a case of substance or honor, the individual knows that he can only count on himself, and that he only has to justify himself to himself. "Honor to you, and shame on you" (*rejala lik wa el 'aib 'alik*), as they say. Each subject acts freely, but it is alone that he must assume any dishonor he may incur. Like the land, like the cooking pot, honor has ceased to be shared.

Le Déracinement, p. 86

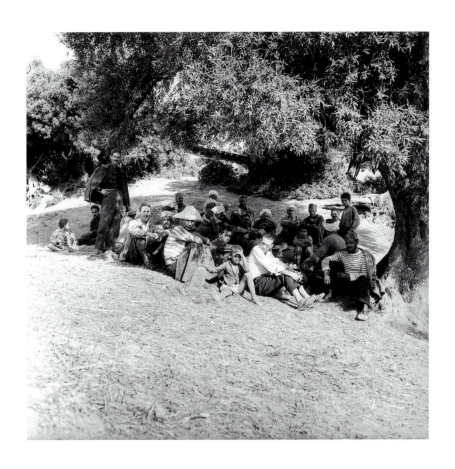

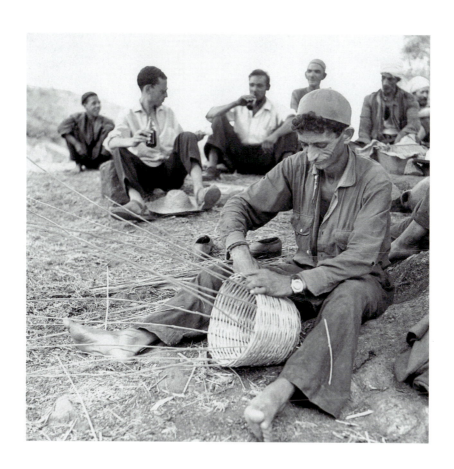

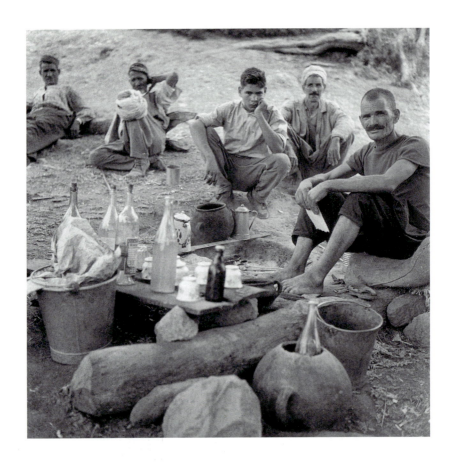

The rural mentality cannot withstand uprootedness for long. Possessed by his property more than possessing it, the farmer is defined by his attachment to his field and his animals. And attitudes to land seem directly related to types of habitat. In Kabylia, given that the habitat is centered on large villages, the farmers do not live on the land itself, which is generally broken up into small parcels, various distances apart. The best ones (*thimizar*) are close to their owners' houses, with which they are connected by paths (*thazribth*, pl. *thizribin*). But some may be either high in the mountains—which means that

they take longer to walk to—or part of another village's territory. And these are obviously the least valued. In most cases they are wholly neglected, or sewn with leguminous plants (*nuwar*). In any case they are not manured, nor are they subject to the triennial rotation of beans, barley, and wheat. Some are so mediocre that they are not cultivated at all. They serve as pasture land, or can boast just a few scrawny fruit trees. But even when, as is sometimes the case, they are several hours' walk away, the farmer "visits" them occasionally.

Le Déracinement, p. 112

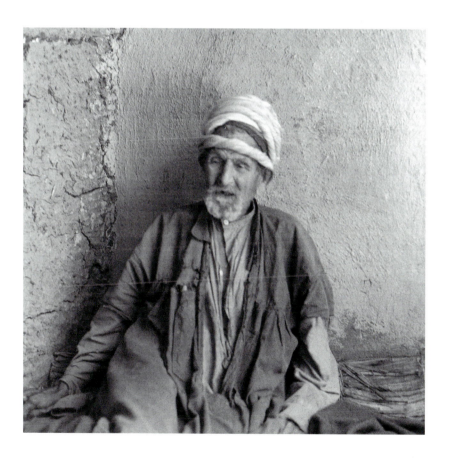

The men of Djebabra and Matmata, though they now do little if any work, still identify themselves as farmers, because any task they carry out is considered customary—not just tilling the fields, but also "visiting" them, or, if this is impossible, observing them from a distance. A man retains his status as a farmer because he inherited it along with the family property; because he was brought up with the virtues that are inseparable from it; because the group has conferred it on him, and he has a duty to display it in all his behavior; and finally, because he cannot dissociate it from his idea of himself. Though pauperization is objectively as widespread here as elsewhere, fellahin who have

been dispossessed of their land remain farmers because they cannot admit to themselves that they have no work, without also disavowing themselves as farmers. And the pride that prevents them making such an admission is the ultimate barrier, when nothing else remains of what gave them their status. Farmers remain farmers for as long as they cannot conceive of themselves as anything else. And this is how their mentality perpetuates itself, as something alien, strange, indifferent, and even hostile to the seduction of other lifestyles they know and reject.

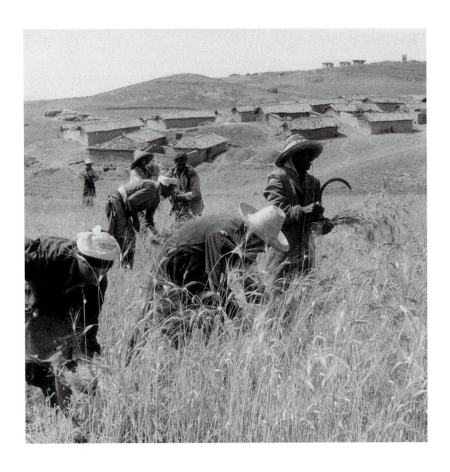

Here again it comes down to attitudes. A farmer may temporarily be a shopkeeper in an Algerian town, a laborer on a large estate, or a worker in a factory in France, provided he does so as a farmer, for the good of the farming community, to increase the family holdings, to acquire a pair of cows, to earn a bride price, build a house, or, simply, feed a family. The authentic farmer, even while living in a town, must remain faithful to his values. And rural society, though not given to paying compliments, is unstinting in its praise of those who have kept faith with its ideals and precepts, and have continued to

live, think, and react as farmers, "following in the footsteps of their fathers and grandfathers." It is said, for example, that "he continues to behave as though he was still living here," or that "he hasn't turned into a *beldi* [city person]," or "he hasn't gotten big-headed." There are two criteria of attachment to farming values. In the first place, one must eat frugally, as a sign that one does not have "too big a belly" and that one does not "work for one's belly." In the second place, women must not (as townswomen do) go out only under the protection of the veil. "She doesn't cross the threshold," as they say, in an expression of commendation addressed to the husband as much as the wife.

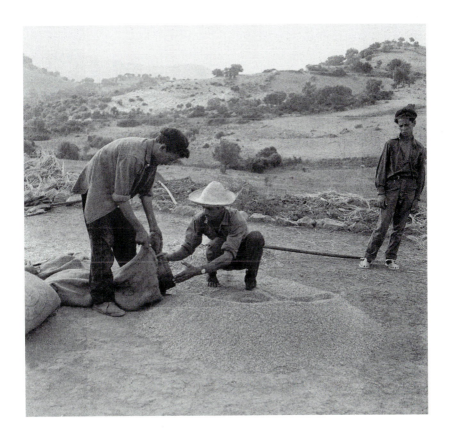

What is disapproved of, above all, is any imitation of townsfolk. To eat like them, to dress like them, to adopt their language or customs would mean disowning the traditions of one's ancestors and offending the entire group. This explains the rapidity with which returnees are restored to their rightful place in society, which they are seen as having vacated only temporarily, out of necessity. The group regards an urban sojourn as an ordeal, to be brought to an end as soon as possible. There is a fear of the exile succumbing to the lures of the city. And in order to allay any suspicion, the returnee must show that he is unambiguously reclaiming his place in the group. The suit he brought back from town must not make any further appearance before the next departure. And there are those who, when leaving for the town, take along the burnous and fez that they will don before setting out on their next trip home.

Le Déracinement, pp. 100–101

It may be that the agricultural crisis is both a symptom and an effect of the difficulties with which traditional farmers, and indeed the farming ethos, are faced. In Kerkera, as in Ain Aghbel, most of the former farmers who declare themselves to be unemployed regret having had to give up the land, and with it their status as farmers. They hope one day to regain their rights as landowners. But they do not want to resume farming immediately, nor have they participated in any major seasonal work (haymaking or harvest, for example), either because they have effectively turned their backs on agricultural activity (which is unlikely) or because they feel that the tasks they have performed are too trivial to mention. In any case, it seems clear that the great majority of them have deliberately stopped working the land and that they are using the resettlement policy as a justification for their unemployed state, even though they could, at least ideally, continue farming. All the aspirations, and all the real efforts, are directed toward the nonagricultural sector—that of permanent paid employment.

Le Déracinement, p. 66

With the future ever more uncertain, the fellahin's behavior tends to be in-spired by a quest for security. The more evasive the present proves to be, the more highly they value it, sacrificing all concern about the future to the satis-faction of immediate needs. For the poorest of them, this spells the end of the foresight prescribed by tradition. And the disruption of time-honored equi-libria removes the minimum of predictability needed to make provision for the future a practicable option. Knowing that whatever they do they will not be able to make ends meet, the fellahin resign themselves to living from day to day, often on credit, supplementing their income from the land by doing a few days' work for the colonizer. Inescapable improvidence is an expression of total skepticism about the future, leading inevitably to fatalistic capitulation.

Le Déracinement, p. 19

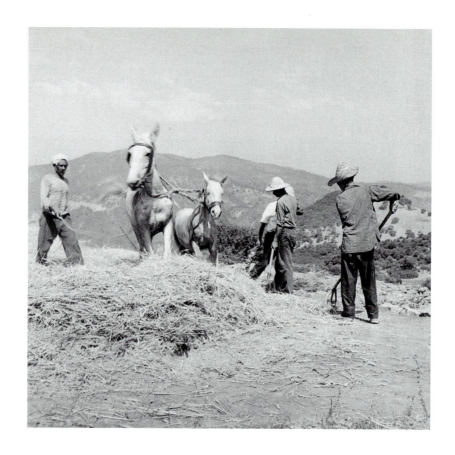

The prospect of making some money is what persuades many farmers to work for others, at harvest time, for example, and sometimes to the neglect of their own land. In April 1963, a fellah from Ouadhia, in Kabylia, having said that he was one of the last real farmers in his village (and this was clear from the way he dressed, talked, and related to his entourage), expressed his regret at the decline of *thafallah'th*, and the shallow seductiveness of the town. "I'm the only man in the village who has a pair of cattle. I do other people's plowing for 2,500 francs a day, and during Ramadan I charge 3,000 francs." (The extra money made up for the meals he did not eat during that period.)

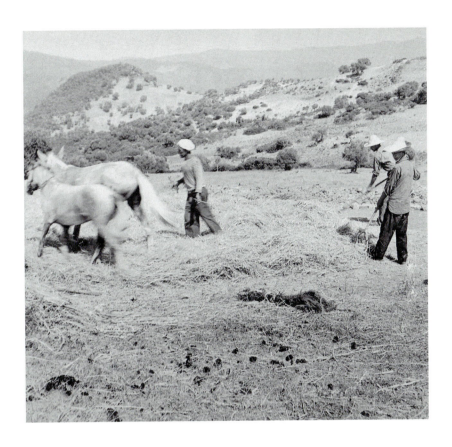

And he was speaking quite casually. But requiring monetary compensation for the nonconsumption of a meal that normally brings together people who participate in collective work is itself a scandalous innovation. And cows are no longer simply the pride of the landowner, or a symbol of his honor as a farmer, but a source of income.

Le Déracinement, p. 71

I remember spending many an hour peppering with questions a Kabyle peasant who was trying to explain a traditional form of the loan of livestock,

because it had not occurred to me that, contrary to all "economic" reason, the lender might feel an obligation to the borrower on the grounds that the borrower was providing for the upkeep of an animal that would have had to have been fed in any case. I also remember all the tiny anecdotal observations or statistical findings I had to put together before gradually realizing that I, like everyone else, had an implicit philosophy of work, based on an equivalence between work and money: the behavior, deemed highly scandalous, of the mason who, after a long stay in France, asked that a sum corresponding to the cost of the meal laid on for the workers at the end of the job—a meal he had refused to attend—should be added to his wages or the fact that, despite working an objectively identical number of hours or days, the peasants of the southern regions of Algeria, where emigration has had less of an impact, were more likely to say they were working" than the Kabyles, who tended to describe themselves as unemployed or jobless. This philosophy which to me (and all those like me) seemed self-evident was something that some of those observed, in particular the Kabyles, were just *discovering*, wrenching themselves with enormous effort from a vision, which I found very difficult to conceive, of activity as *social occupation*.

The Social Structures of the Economy, pp. 3–4

The groups of workers at the colonists' farms represent one aspect of a tendency to fragmentation that the resettlement movement has speeded up, though without carrying it through to completion, first because the duration of the process has been too short for the most profound transformations to have taken place, and second because a strong feeling that this is merely a transitory ordeal has tempered the "efficacy" of the disruptive action. One can see the CAPER movement at Ain Sultan as a symbol of the Algerian farming community's history over the last ten years: Workers who had spent long years on the estates were reminded of their past by their mountain colleagues, at a time when the uprooting, dispersal, and disorganization of the group placed the collective memory under threat.

"Paysans déracinés, bouleversements morphologiques et changements
culturels en Algérie," p. 94

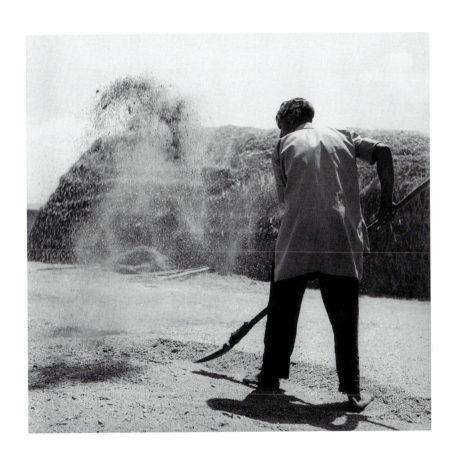

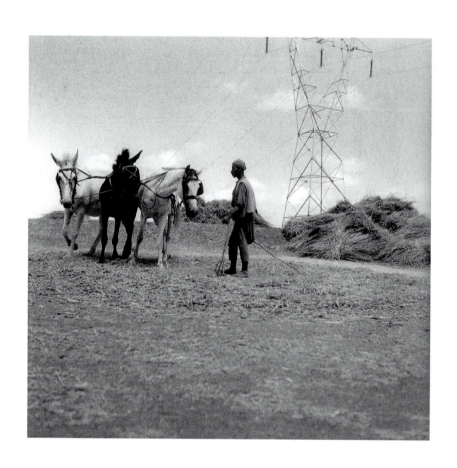

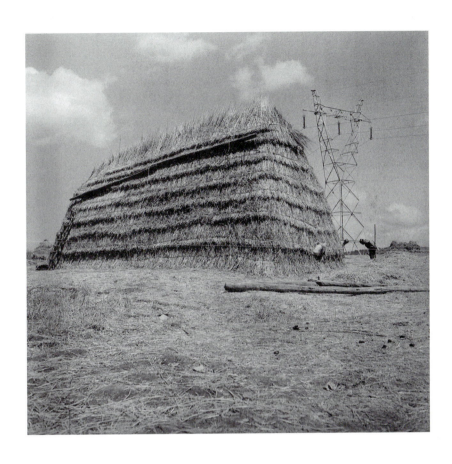

Since they lacked these "predispositions," which the spontaneously Millian schoolchildren of Lowestoft had imbibed with their mother's milk, the economic agents I was able to observe in Algeria in the 1960s had to learn or, more exactly, *reinvent*, with greater or less success, depending on their economic and cultural resources, everything economic theory considers (at least tacitly) as a given, that is to say, everything it regards as an innate, universal gift, forming part of human nature: the idea of work as an activity procuring a monetary income, as opposed to mere occupation on the lines of the traditional division of activities or the traditional exchange of services; the very possibility of impersonal transactions between strangers, linked to a market situation, as opposed to all the exchanges of the economy of "good faith," as the Kabyles call it, between relatives and acquaintances or between strangers, but strangers "domesticated," so to speak, by the provision of guarantees from close relations and intermediaries capable of limiting and averting the risks associated with the market; the notion of long-term investment, as opposed to the practice of putting in reserve, or the simple anticipation that forms part of the directly felt unity of productive cycles; the modern conception, which has become so familiar to us that we forget that it once gave rise to interminable ethical and legal debates, of lending at interest and the very idea of a contract, with its previously unknown strict deadlines and formal clauses, which gradually supplanted the honorable exchange between men of honor that excluded the calculation and the pursuit of profit and involved an acute concern with fairness etc. These are all so many partial innovations, but together they form a system because they are rooted in a representation of the future as a site of "possibles" that are open and susceptible to calculation.

The Social Structures of the Economy, p. 4

Work is neither an end in itself nor a virtue per se. What is valued is not action directed towards an economic goal, but activity in itself, regardless of its economic function and merely on condition that it has a social function. The self-respecting man must always be busy doing something. If he can find

nothing to do, "at least he can carve his spoon." "The unoccupied shepherd," runs another saying, "carves his stick." A lazy person is not fulfilling the function incumbent upon him as a member of the group: He thereby sets himself on the edge of society and runs the risk of being cast out. To remain idle, especially if one belongs to a great family, is to fall down on one's commitments to the group, to avoid the duties, tasks, and responsibilities that are inseparable from membership in the group. So, for example, a man who has been out of farming activity for some time, whether on account of illness or emigration to France, is rapidly reinstated on his return into the cycle of work and the circuit of the exchange of services. The adolescents of poor families, the sons of widows, are told: "Go and hire yourselves out (*charkath*), you'll become men by holding the plow and digging the earth." Because the group is entitled to demand of everyone that he undertake an occupation, it is also obliged to make sure that everyone *has* an occupation, albeit a purely symbolic one. The farmer who provides an opportunity to work on his land for those who have no land to plow, no plow to hold, no trees to prune, such as the sons of *khammes*, farm laborers, or widows, is universally approved, because he is giving these marginal individuals a chance to integrate themselves into the group, in short, to become complete men.

In such a context, what must appear as a state of merely being occupied when one implicitly relates it to the conception of labor as productive activity, was not and could not be perceived in that way. Thus, the head of the family was naturally the oldest member, because his work, in his own eyes and in those of the group, was identified with the very function of the head of the family, responsible for each and for all, charged with ordering and organizing work, expenditure, and social relations. The distinction between productive and unproductive labor, like the distinction between profitable and unprofitable labor, was relegated to the background; the fundamental opposition was between the idler (by circumstance or inclination) who fails in his social duty and the worker who fulfils his social function, whatever the product of his efforts.

Algeria 1960, pp. 24–25

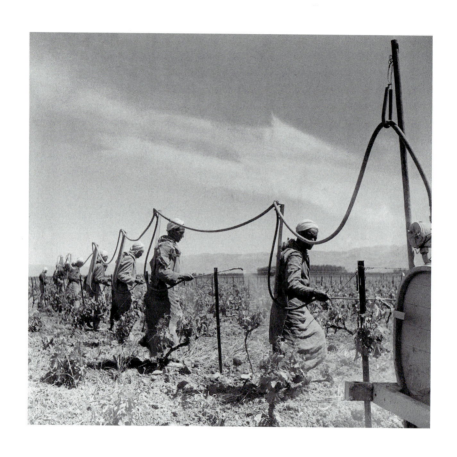

The break with farming and the denial of the corresponding ethos represent the culmination of a purely negative process that must result either in a flight from the land to the towns or a resigned acceptance of a devalued, denigrated condition, but not the invention of a new type of relationship with the land, or with working on it. This is the end of "peasant" farmers, though for the moment there are few modern farmers. In other words, each village still has a few "laggards" who obstinately perpetuate an outmoded art of living, and also a handful of farmers who apply the rules of economic rationality. But the opposition between traditionalist and modern farmers is now purely heuristic, and useful only for identifying the extremities of a continuum in which behavior patterns and attitudes are separated by a multitude of infinitesimal distinctions.

Le Déracinement, p. 161

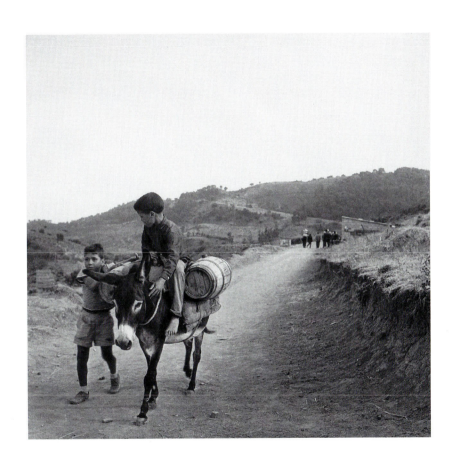

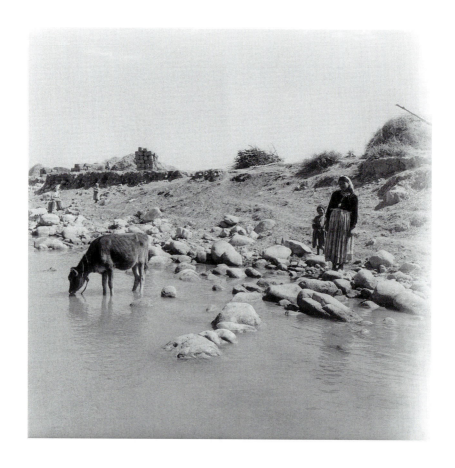

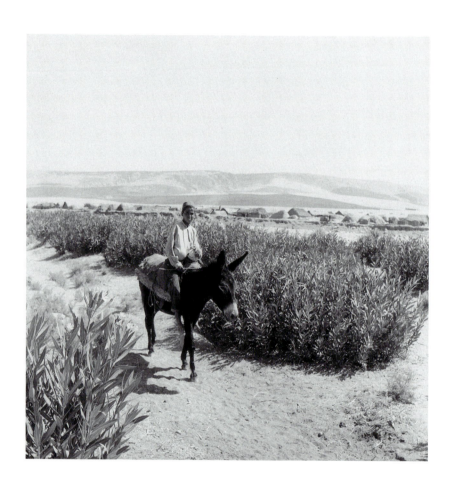

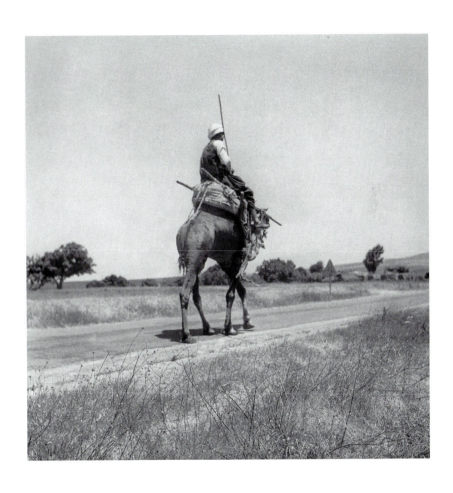

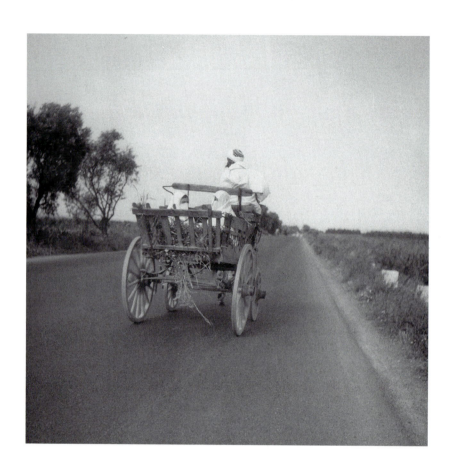

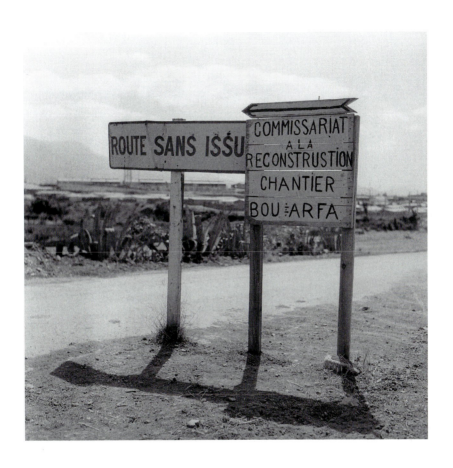

THE ECONOMICS OF POVERTY

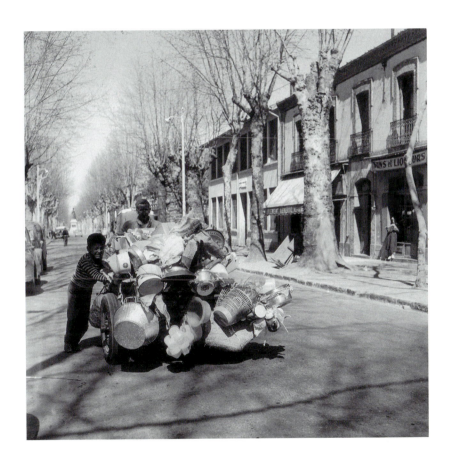

"These days, it's all a question of profession (*al mityi*). 'What's your profession?' That's what people want to know. Everybody's inventing professions for themselves. Some guy puts four boxes of sugar and two packs of coffee on a stall, and calls himself a shopkeeper. Some other guy who can nail a few planks together sets up as a carpenter. There are taxi drivers all over the place, and they don't even have a car, just a license." (Fellah, Djemaa-Saharidj.)

Le Déracinement, p. 61

"Sometimes I work, sometimes ten days, sometimes two weeks; but never continuously. At the moment I'm working on a building site as a driver. The kids need bread. And as far as that goes, any job will do. It's better than sitting around idle, twiddling my thumbs, not doing anything for them. Look at my kids—they're stark naked. Look at my house—it's not a house, it's a stable. I'd take any job just to be able to feed my kids. The problem is, there's nothing else I can do. That's my life, except the pay's lousy. But that's all we're good for." (Driver, Oran.)

Travail et travailleurs en Algérie, p. 503

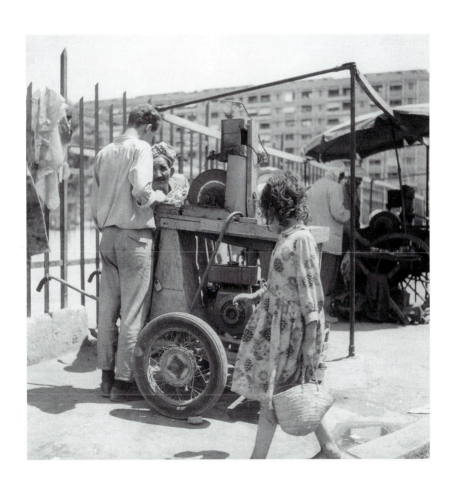

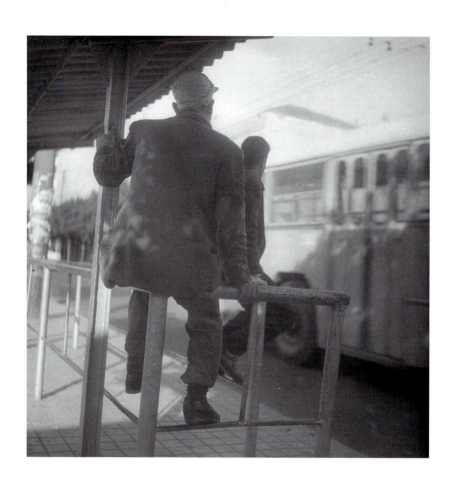

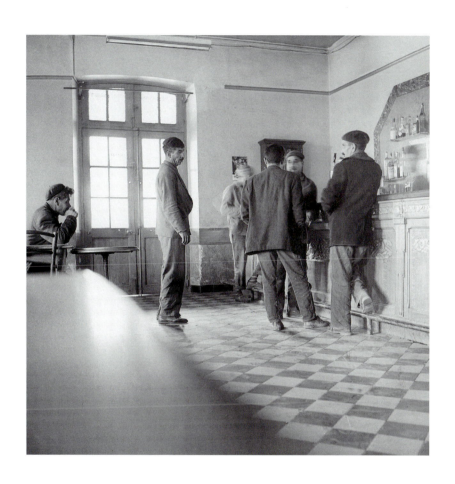

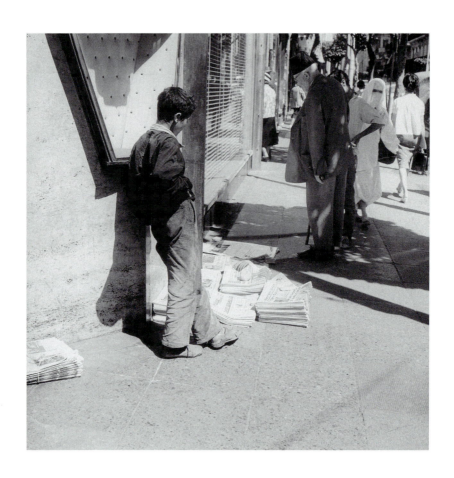

If "work" means a profession, a steady job that allows a person to live decently, it's not for everybody, and it's something else. If "work" means doing anything at all to earn your living rather than just sit there with your arms folded, it's only shirkers who don't work. A man with dignity, who doesn't want to scrounge off other people, even if it means living by his wits, has to work. If he can't find work, he can still sell things in the street. Lots of people have had to do that to get by, and now they wouldn't do anything else. Which is bad, because something that started off as a necessity ends up as a form of laziness.

"I'm a fellah. My father came to the town because we couldn't get by any longer. I knew a bit about cutting hair. I learned it on my own. I couldn't do anything else, so I started doing that. I rent a place; I pay 3,000 francs rent. It's tough. I learned my trade by just doing it. But I've never had a steady income; there's a lot of competition. You're never sure of anything, in this line of work. What I earn buys bread for my kids, but only just. Only just. When I don't make enough, a grocer I know gives me credit. I'd get a different job if I could . . . I'd like *them* to be machine operators, mechanics, something like that. Anybody with a skill has it made; they don't have to think about tomorrow. In a situation like mine, you're always teetering on the brink. How do you expect me to do anything worthwhile? I can't even imagine setting up the way I'd need to. I should consider myself lucky to earn a crust. And there's no point thinking about the rest."

Travail et travailleurs en Algérie, p. 511

If the pressure of the "industrial reserve army" is always deeply felt, it is sometimes expressed explicitly, either in vague and general judgments—such as "there are many hands," "there are many people," "there are too many people," "the population has doubled"—or in more concrete terms, that are closer to lived or ongoing experiences: "Go down to the wharf one morning and you'll see: there are hundreds, thousands waiting for work—for one day's work, just to feed their kids." (Laborer, Algiers)

Travail et travailleurs en Algérie, p. 533

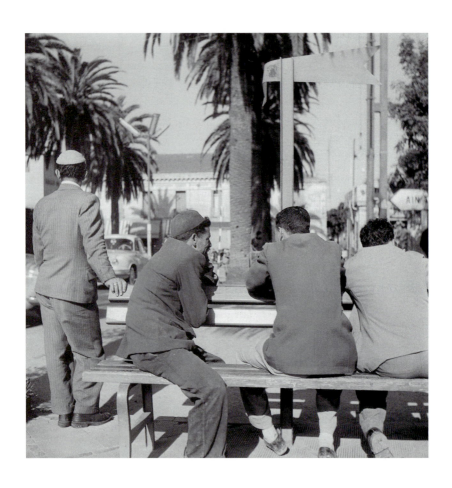

The entire existence of these day laborers, casual workers, unemployed people and street traders who bring rural attitudes to an urban environment and cannot make the changes necessary to adapt to urban life revolves round necessity and insecurity. "Sometimes I work for a day, sometimes four days; and sometimes I'm out of work for a whole month. I have almost 5,000 francs of debt. I borrow from one person to pay back someone else; it's always the same. I have no trade, no education—how am I supposed to live? I work as a laborer; I carry water and stones for construction work. . . . Ah, if I could just find a job! You see how I'm trapped (*makhnouq*, literally, "strangled"). When I don't have any laboring work, I go off to town and work as a porter in the market. I borrow money left, right, and center. I borrow from Peter to pay back Paul. I leave at 5 a.m. Off I go. I keep looking, I keep looking. Sometimes I return at midday or 1 o'clock, and there's still nothing. Nothing! . . . What I earn, it's like my work, never regular, never steady. What can you do? *When you're not sure about today, how can you be sure about tomorrow?* I make around 10,000 francs, on average. I'd do anything at all to be able to buy bread for my family." (Laborer without regular employment, Constantine)

Travail et travailleurs en Algérie, p. 352

A daily grind divided up between looking for work and finding some, here and there, with the week or the month fragmented by unpredictable employment and idleness—everything bears the stamp of precariousness. There is no regularity, no fixed workplace. Time and space are marked by the same discontinuity. Looking for work is the only constant feature of this existence, which is at the mercy of chance, and beset by the constant failure of the quest. Looking for work "right and left," borrowing "right and left"; borrowing with the right hand to pay back with the left. "*I keep borrowing like a piece of peel on the water,*" said an unemployed man from Constantine.

Travail et travailleurs en Algérie, p. 353

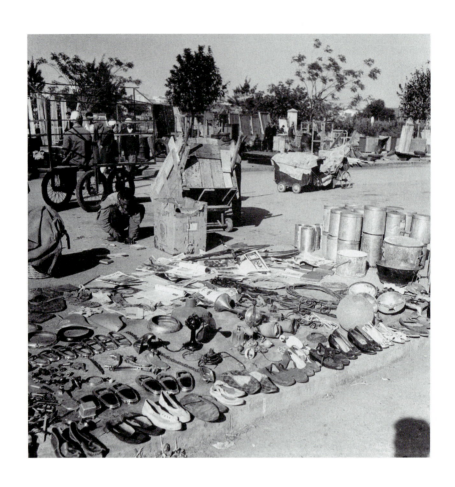

"I leave in the mornings to look for work. I don't stay in. How could I? The house is a furnace during the day and an icebox at night." You leave each day in search of work, pretty early, depending on whether you're really hopeful or are just resigned to it. You spend all morning going from one building site to another, relying on the advice of a friend, cousin, or neighbor. You don't even return home at noon. Instead you spend the afternoon at a café or eat and smoke with friends. Searching for work has become a kind of profession for us.

Travail et travailleurs en Algérie, p. 356

The sole purpose of activity is to satisfy immediate needs. "I earn a crust of bread and that's it." "What I earn, I eat" "I earn just enough to buy bread for my children." "I work just to feed the children." The ancient tradition of foresight has come to this. The city dweller begins to resemble the image the traditional peasant had of him: "What was earned during the day was eaten at night." At times, one sees traditional behavior reemerge, completely aberrant in this new context, and inspired by the haunting of subsistence. "I've put aside some provisions," says a grocer from Oran who earns 400 to 500 francs per day. "Even if I don't make anything, I can still eat." The traditionalism of despair, as inconsequential as day-to-day existence. How can one hope beyond the present, beyond subsistence, when this primordial goal is barely satisfied? "The salary is only for buying bread. But to rise above that, no." (Laborer in a fish market, Constantine.)

Because sacrifices relate primordially to consumption, incomes can increase without concomitant savings, or even the thought of it, since needs exceed means: It is known, in fact, that the role of food grows in proportion to income in family budgets, up to a certain threshold. When asked if they save, most of the lower-class workers answer with a laugh or indignation: 5.4% of such workers have savings and 50.9% have debts. "Savings?" says a driver from Orléansville with a smile. "When I get my pay, I'm sick. I don't know what to do with it. I live day-to-day."

Travail et travailleurs en Algérie, p. 357

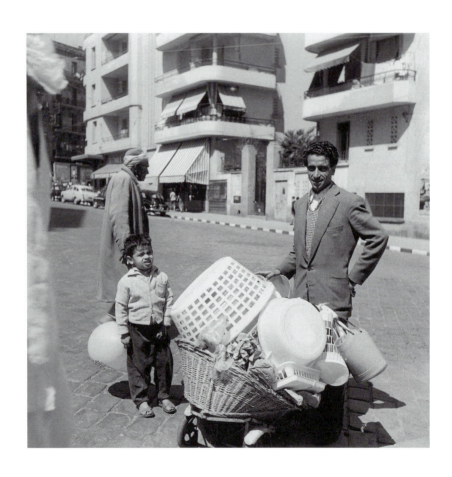

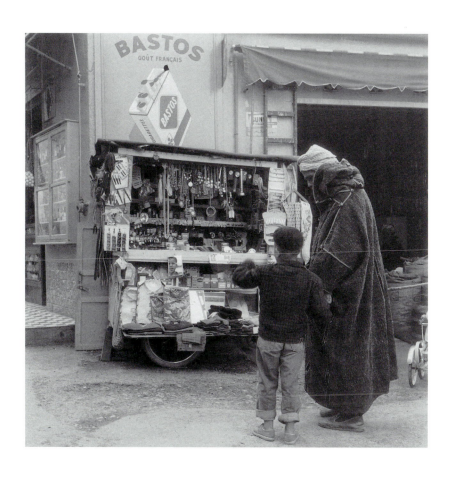

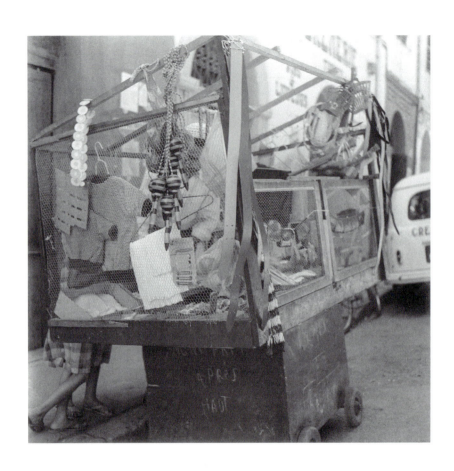

The climate of melancholy denotes disarray and anxiety, and a weakening of ancient solidarities. The reason poverty has affected people so traumatically is that it has precipitated the collapse of a value system that insisted on the identification of the individual with the group, and thereby provided protection against solitude. If the group can no longer exercise a regulatory function, this is due not only to uncertainty about its norms and values, which have been undermined, but also to the fact that, as it were, the deepest structures have been broken. Forcible displacement and arbitrary manipulation have transformed the substrate of social life, not only in its extent and breadth, but also in its form. The resettlement process, whose imposition bears no relation to economic logic, affects all of social life by transforming the organization of the inhabited space that projects social structures onto the terrain, and by breaking the bonds of familiarity that connect individuals to their environment. The farmer's world is the one he was born into. His physical habitus has been shaped to fit the space of his customary movements; and resettlement affects him so profoundly that he cannot even formulate his sense of helplessness, let alone identify the reason for it.

"Paysons déracinés, bouleversenents morphologiques
et changements culturels en Algérie," p. 87

With no expectation of anything beyond harvests that will provide them with enough to survive on, the most impoverished must choose between the fatalism of despair, which is foreign to Islam, and departure for a town, or for France. Rather than the result of a freely made decision based on a real desire to adopt an urban lifestyle, enforced exile is often just the inevitable result of repeated surrenders and defeats. A poor harvest means that the donkey or the cows will have to be sold; money must be borrowed at an exorbitant rate of interest to pay for repairs or to buy seed. And finally, having run out of options, it is not a question of leaving; it is a question of escaping. Or again, tired of working so hard and living so wretchedly, people go off in search of better times, abandoning their land to a *khammes*. In any case, moving to a town signifies a headlong flight dictated by poverty. Those who have some financial resources set up as shopkeepers in the nearest small town, whose

market they have been accustomed to frequent. Apart from traditional crafts, this is the only kind of activity open to landowners who wish to avoid losing status, especially if they stay in a region where everyone knows them. The small dispossessed landowners, the former *khammes*, the agricultural laborers who are totally unprepared for urban life and who have neither the aptitudes nor the attitudes needed to adapt, can hope for nothing better than to end up as day laborers or street hawkers, or to remain unemployed pending their admission to the "paradise" of permanent employment.

Le Déracinement, pp. 20–21

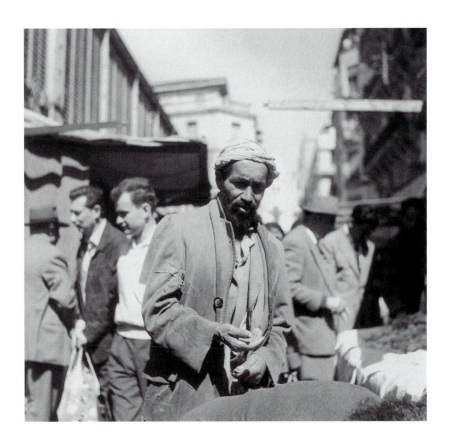

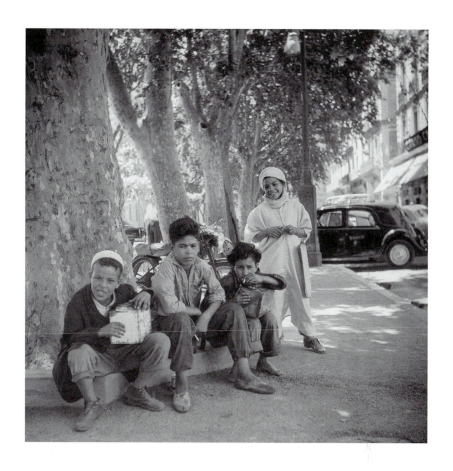

"Let me tell you," says a deliveryman from Oran, "my parents weren't educated, *and they didn't know what the future held*. Personally, instead of earning 100 francs, *I prefer to work four times harder for 200 francs*, and bring up my children. And that's just what I'm doing. My competitors complain, but they can shout all they want; they earn twice as much as me, and I work twice as hard as them."

<div align="right">

Travail et travailleurs en Algérie, p. 207

</div>

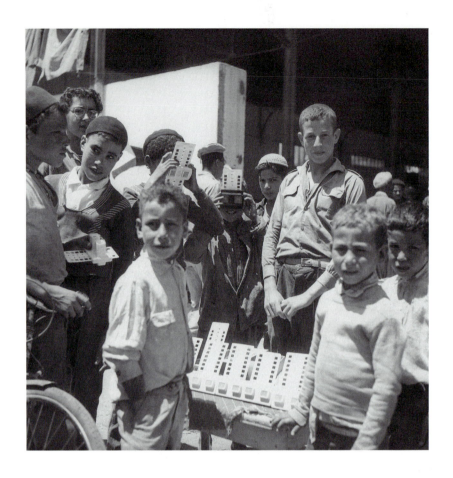

An unemployed man from Constantine, devoid of all resources, estimates that he needs 2,000 NF a month to satisfy the needs of his family. When asked about the future he hopes for for his children, he says: "They would go to school, and when they become sufficiently educated, they would choose for themselves. But I can't afford to send them to school. I would like, if I could, for them to go to school long enough to become doctors or lawyers, but I have no help. *I'm allowed to dream.*"

Travail et travailleurs en Algérie, p. 300

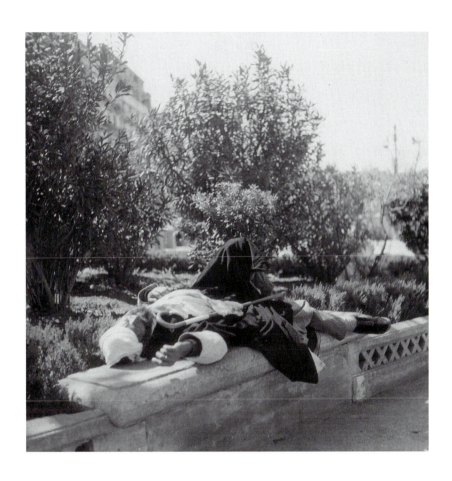

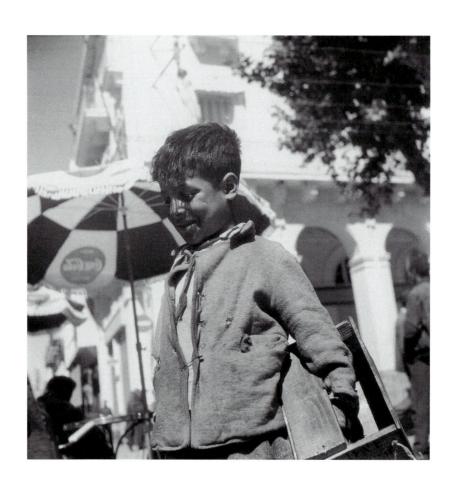

I'd been around, all right! Before I did my military service I was delivering per-
fume for L. . . . I worked for five years. I was 17. There wasn't any—I couldn't
do anything else. At that time, everything was out of bounds. It's always the
same, as I told you: The Europeans grab all the jobs. Actually I have a story
for you. I remember, as if it was just yesterday—it really struck me. In Rue Mi-
chelet there was a place that was looking for an apprentice tailor, and I'd just
left school. The boss said to me, "Can you read?" "Yes." "Write?" "Yes." "You
have your school certificate?" I showed it to him, and he took a look at it. At
that very moment, a young lad around my age came in. I can still remember it
to this day. He couldn't speak a word of French. I thought the boss was going
to give him a test. But he said to me, "Monsieur, you may go. We'll write to
you." Well, I got no news. The guy was Spanish. I'll never forget that.

Travail et travailleurs en Algérie, p. 461

"If you want a decent job, you have to get some strings pulled! [Energetic
handwaving] You need some broad 'shoulders'![1] You need 20,000 or 40,000
francs for baksheesh. But that's just a guess; I don't really know. Mind you,
there's a second way. If you have a friend or a relative, maybe they can help
you. But the main way's 'stringpullmoney.'" (House painter, Oran)

Travail et travailleurs en Algérie, p. 464

It all depends. It's God and luck. None of my business. It's all down to fate.
You have to give presents to the bosses, backhanders to the foremen. That
way, sure, you can find work.

The wife: Everybody works whatever way they can.

The husband: Maybe you think you're in France, where there are factories!
But there's nothing at all here! (Egg seller, Tlemcen)

Travail et travailleurs en Algérie, p. 473

An unemployed man lives in a shack in Oran (2 rooms, 3 meters by 2; no fur-
niture) with his father, who occupies one of the rooms, his sister and her son,
all of whom are dependent on him. He says that after selling prickly pears

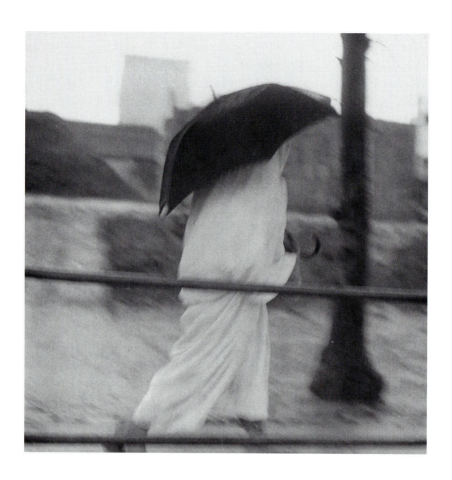

for a month he stopped four days ago, because his hands were suffering. "I'm looking around all the time. I haven't really worked for two years. I'd like to get a job as a laborer, but you need a work permit, and I don't have one. To get a permit, you have to have worked six months in the same firm. It's Algiers that issues them. I put in a request at the town hall, but I haven't had any reply. I was selling bottles in the street, making 200 or 300 francs a day. It was better than nothing. Better than now." And his sister adds, "He can't buy milk for his son. His wife went back to her father—she'd had enough of not eating."

Travail et travailleurs en Algérie, p. 502

"I've been in Constantine since March 1959. Before that, I was in Châteaudun du Rhumel. I arrived in the shantytown of Hatabia. The shacks were pulled down, and we were 'rehoused' in the El Biar suburb. The house belongs to the SAS. There's no water or electricity. There are eight of us in two rooms, one for my brother and one for me. My grandfather—I don't know what he did. My father was a day laborer: pick and shovel, and off you go, fellah. I worked as a 'trabajar.'[2] Now I'm unemployed. I look for a job every day at the building sites, but I haven't found anything yet, either in Belleville or anywhere else. I'd do anything at all, if I could find something, just to get a crust of bread for my children. But I don't have any skills. People with a specialty get hired right away; it's impossible for them to be out of work." And his brother adds, in French, "He's been looking everywhere for work, but there's none.— I'd do any kind of job, anything at all [in French], but I don't have any skills. People who have a skill are never out of work for long." (Unemployed man, Constantine)

Travail et travailleurs en Algérie, p. 502

IN ALGIERS AND BLIDA

Image Sequence

PIERRE BOURDIEU

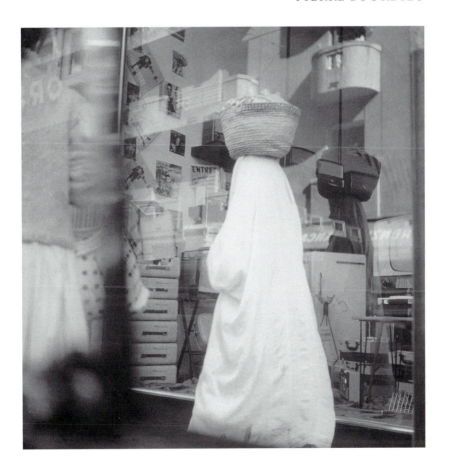

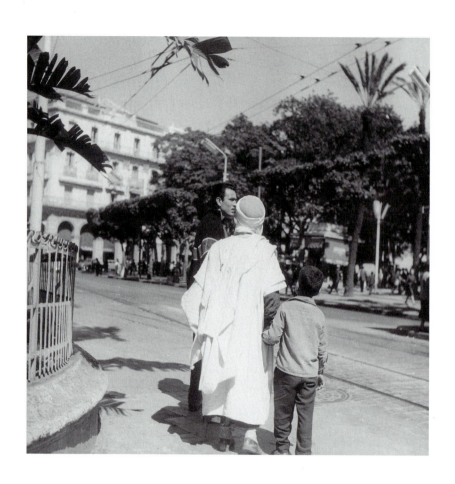

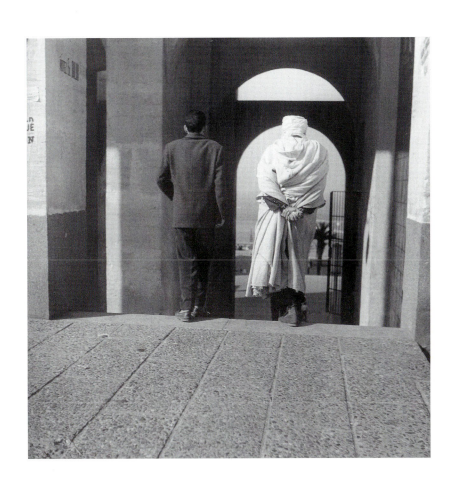

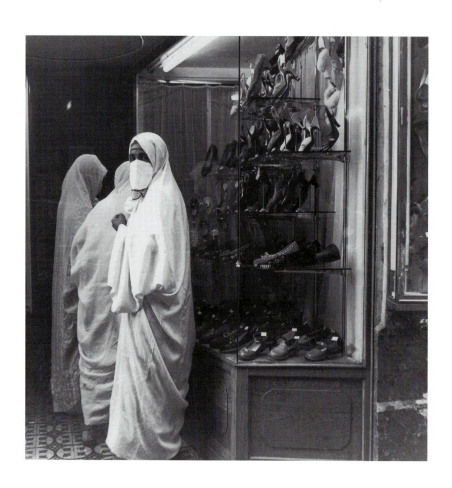

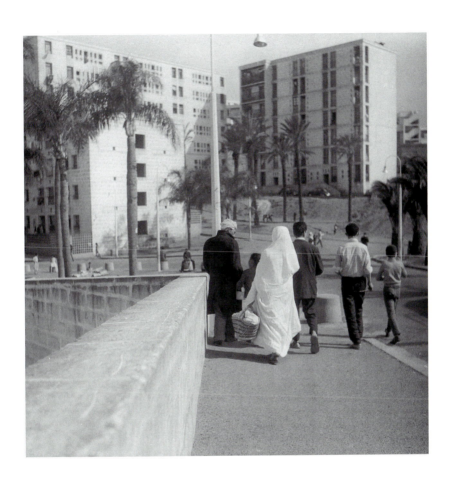

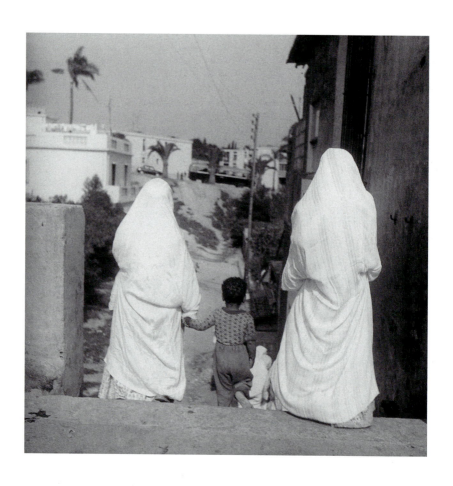

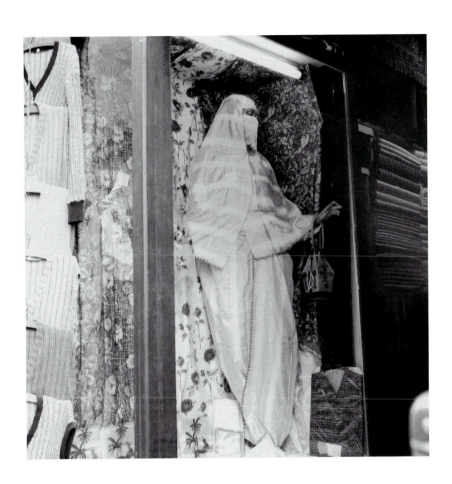

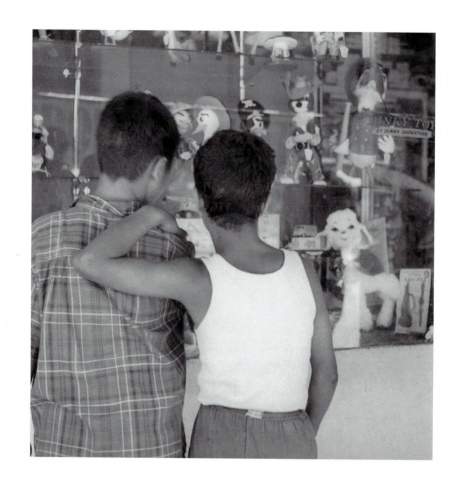

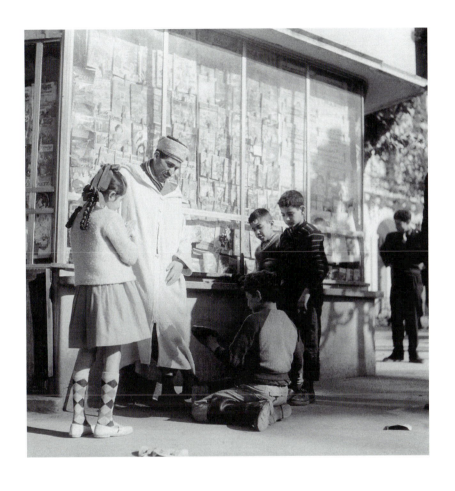

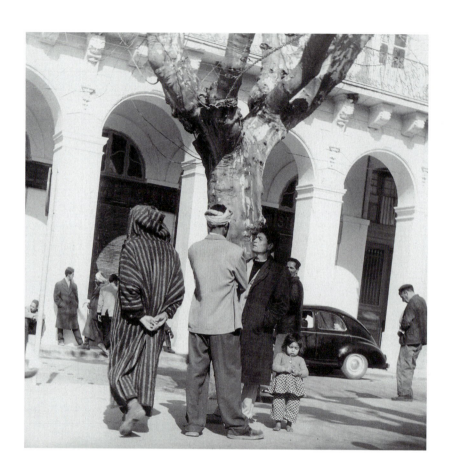

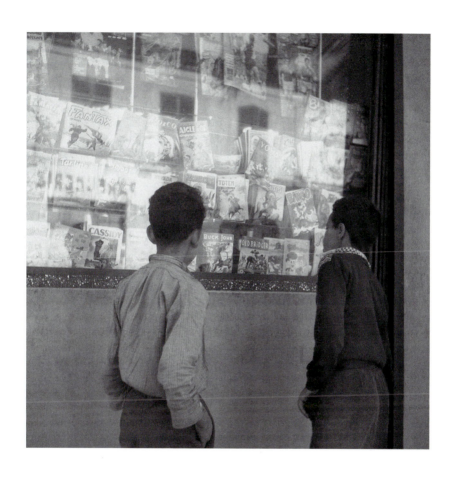

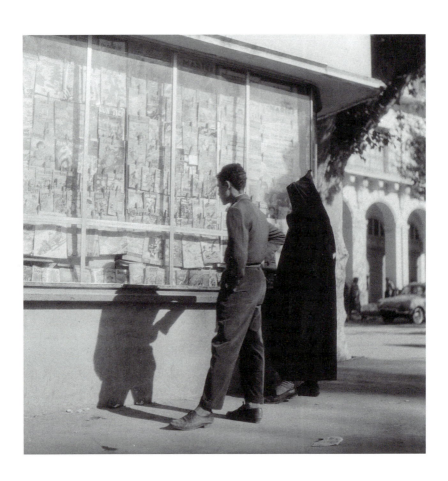

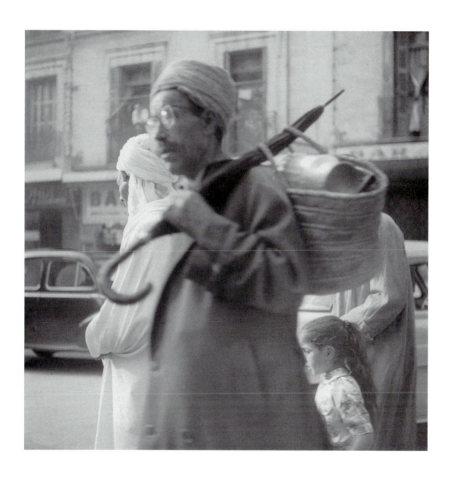

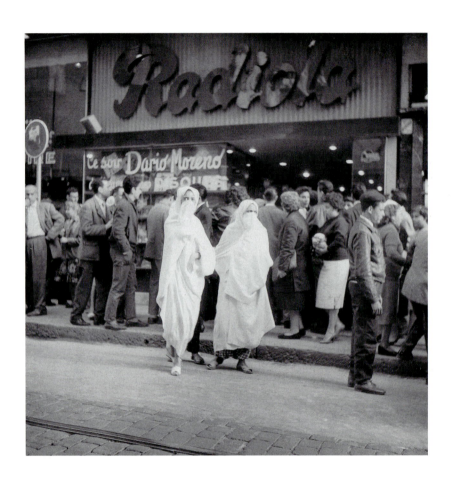

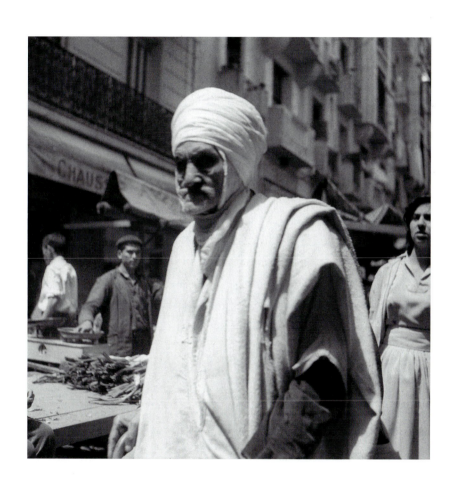

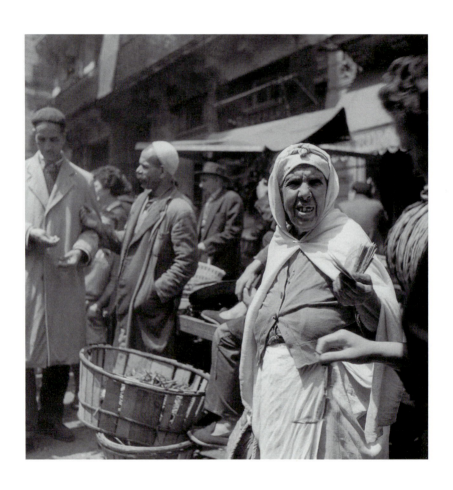

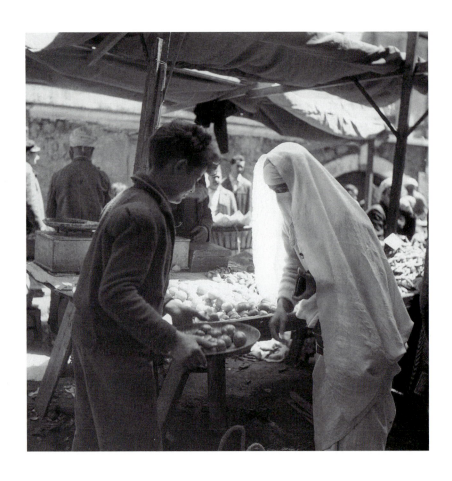

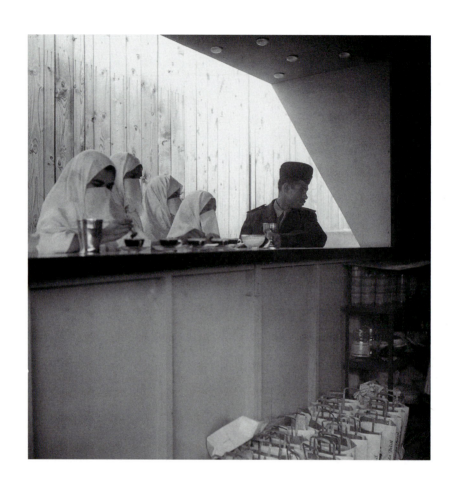

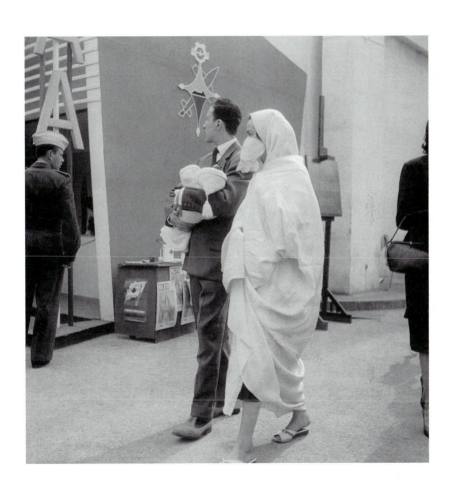

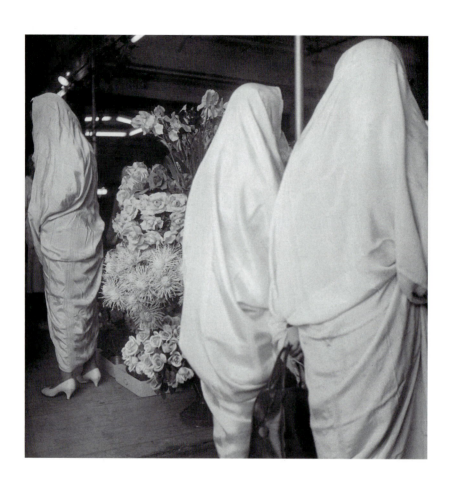

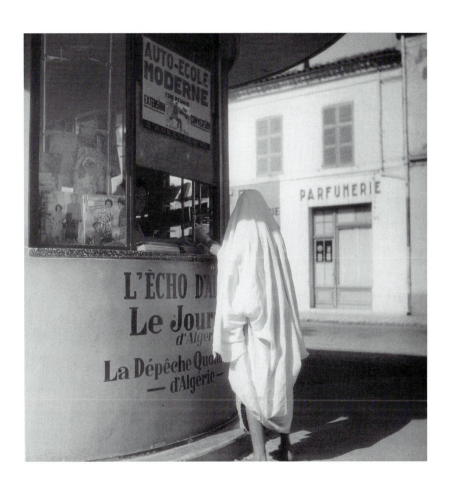

COMMENTS ON
THE PHOTOGRAPHIC
DOCUMENTATIONS
OF PIERRE BOURDIEU

CHRISTINE FRISINGHELLI

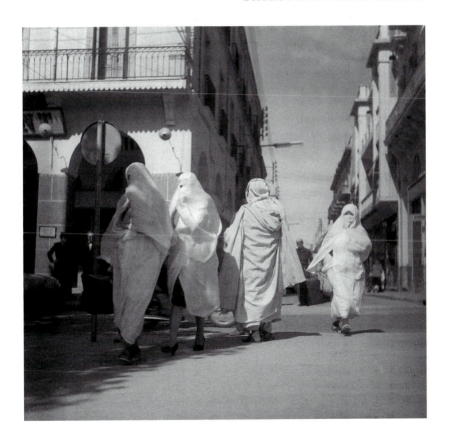

This exhibition and the accompanying book present the first extensive se-
lection of Pierre Bourdieu's photographic documentations to the public,
material that Pierre Bourdieu—with some few exceptions—refrained from
publishing for more than forty years. The photographs assembled here were
taken in Algeria in the years between 1958 and 1961 and add an important
facet to Bourdieu's ethnographic and sociological studies at a time marked by
the tragic circumstances of the colonial war.

In an interview held by Franz Schultheis with Pierre Bourdieu for *Camera
Austria* photographic magazine—which marks the start of the joint work on
this project—Bourdieu sets his photographic practice in the context of his
anthropological and sociological work, commenting on it in a retrospective
of what was for him a crucial period in Algeria, his emotional ties to this
country, his respect for its people, whom he sought to vindicate in all of his
works. He was interested in photography in several respects: It represents the
detached observation of the scientist and, at the same time, makes us aware
of the very fact of observing; it allows us to capture details, immediately and
from an intimate distance, that we may overlook or not be able to study in
depth at the moment of perceiving them. Photography is "interwoven with the
relationship that I have had to my subject at any particular time, and not for
a moment did I forget that my subject is people, human beings whom I have
encountered from a perspective that—at the risk of sounding ridiculous—
I would refer to as caring, often touched."[2] These pictures are also a means of
communicating with the people in whom Bourdieu was primarily interested:
peasants without land, deported to the Centres de Regroupement (resettle-
ment camps), compelled to inactivity or stranded in the cities; families whose
status is threatening to break up, subsisting under miserable conditions in the
cities; the poverty of the unemployed and the uprooted millions.

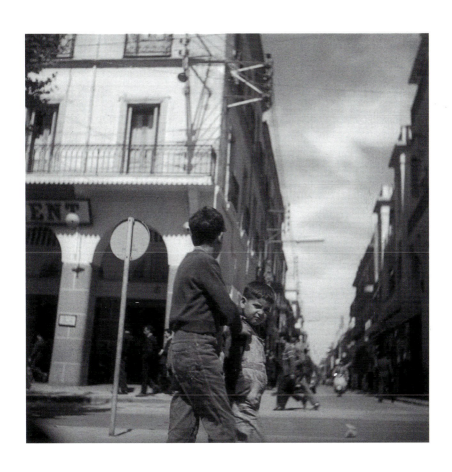

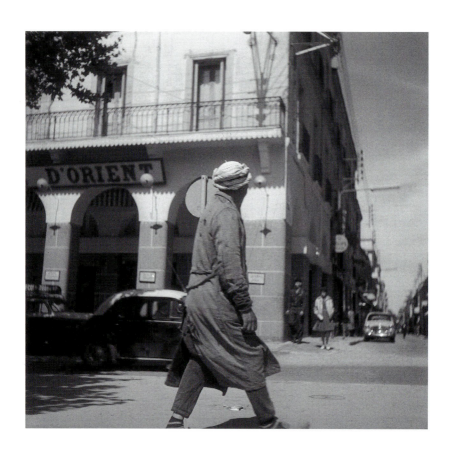

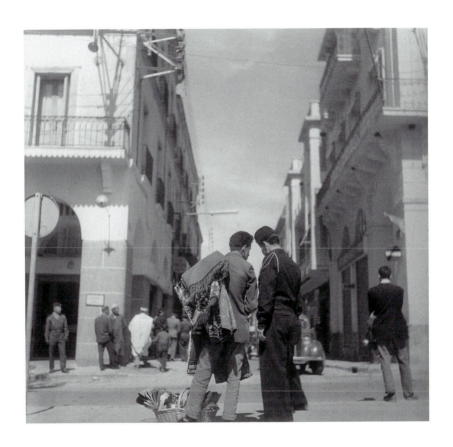

But these photographs are above all the result of scientific work, and in this sense they must be viewed in a constructive context together with the texts that he wrote at the same time, and thus have a specific historical and thematic framework. The first task in our work, then, was to scrutinize the photographic documentations for contexts that Pierre Bourdieu analyzes in his writings. We attempted to read Pierre Bourdieu's archive and all the circumstances of this collection of negatives and prints, comments and the collection of sketches contained in the *fiches d'Algérie* (collection of notes from Algeria), in the context of Bourdieu's studies. Pierre Bourdieu himself had already begun to tentatively combine pictures and texts, and we were able to follow this model.

After these photographs were taken, Pierre Bourdieu published only a few of them; the vast majority of his photographic documentations has so far remained unknown. Those familiar with Bourdieu's work will recognize the photographs that were chosen as cover pictures for the first editions of his books: *Le Déracinement* (with Abdelmalek Sayad); *Travail et travailleurs en Algérie* (with Alain Darbel et al.); *Algérie 60*, and *Le Sens pratique*. But photographs from the collection were also used for articles and magazine interviews. Numerous photographs used in publications, however, can no longer be found in the archive, and in some cases there is not even a negative, as a great many of the perhaps 2000 pictures taken in the four years of work were lost during moves. The archive currently comprises 600 negatives (format 6 cm × 6 cm) and 199 contact and work prints (format between 6 cm × 6 cm and a maximum of 12.5 cm × 12.5 cm).

The main body of the archive, alongside the negatives, comprises 146 large-format prints with a format of 23 cm × 23 cm and a smaller group with a format of 30 cm × 30 cm that Pierre Bourdieu collated in three themed albums. There are no negatives of 26 of these 146 prints (i.e., these prints are now the only sources available to us). All titles and dates are given by Pierre Bourdieu; place names have been added where it was possible to derive them unequivocally from the photos or from publications. We retained the

numbering of the negatives as the archive numbers of the pictures, with a system of letters indicating whether the archive contains an original print with a negative (O), an original print without a negative (R), or only the negative (N). Finally, we created work prints from all negatives and scans of all original photos and the main pictures of the exhibition and book so as to avoid the risk of further damage to the originals.

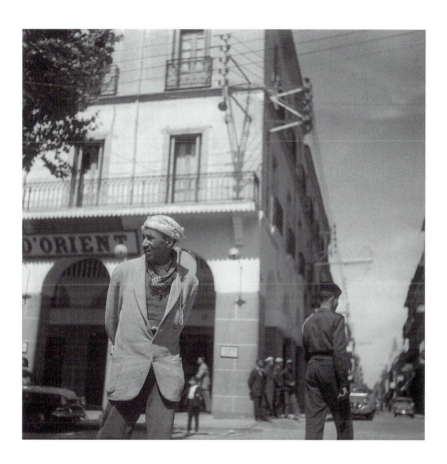

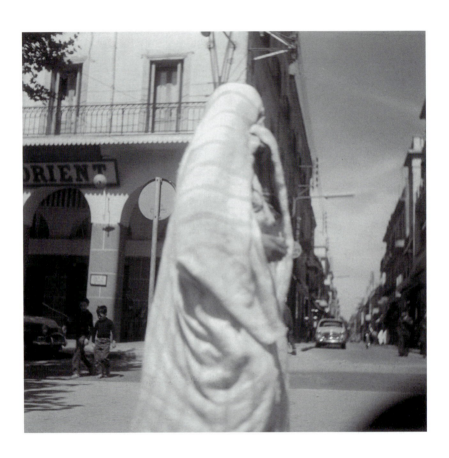

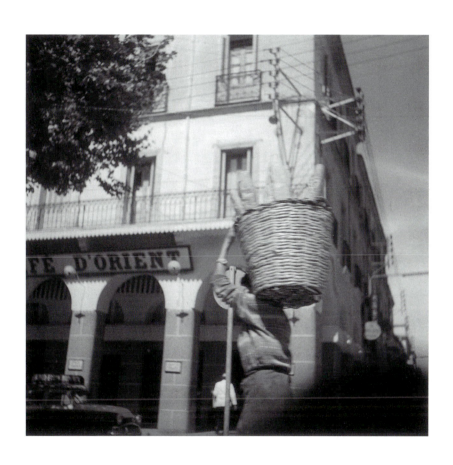

The photographs published by Pierre Bourdieu himself were important guidelines for selecting the photographs that were to be presented in the exhibition and the book, as were the pictures that he commented on in his interview about Algeria. Almost all the existing exhibition-format prints were included, as we feel that they represent pictures already selected by Bourdieu. Pierre Bourdieu had compiled these prints in three photo albums. The arrangement of the photos in the albums and the handwritten comments were recorded so that we could use them as guidelines for thematic groups. Our editorial and curatorial work was intended to convey to the viewer/reader what decisions Bourdieu made—in his photography and with regard to the selection and arrangement of the pictures—and, at the same time, to visualize the situation of the archive.

Pierre Bourdieu describes the production conditions of this documentation, which was created methodically but at the same time under great emotional pressure, as follows: He intended, for example, to describe types of clothing in order to relate the different possibilities of combining European and adaptations of traditional clothing with the social traits of their wearers; he secretly recorded conversations in public places with the idea of investigating the conditions of transition from one language into another; he conducted interviews with informers, questionnaire surveys, evaluation of archives, tests in schools, and discussions in welfare centers. "This somewhat exaggerated *libido sciendi*, engendered by a passion for everything connected with this country and its people, and also by the secret and constant sense of guilt and resistance in view of so much suffering and such great injustice, knew no respite or limit. . . . The simple wish to assimilate all of these events in myself induced me to continue a dogged task with my heart and soul that enabled me to be up to the experiences whose unworthy and helpless witness I was, and of which I wanted to render an account at all costs."[3]

Pierre Bourdieu's photographic work in Algeria in the 1950s is set in the tradition of committed humanistic photography as we know it (also in terms of the similarity of content) from the large-scale documentations of poverty

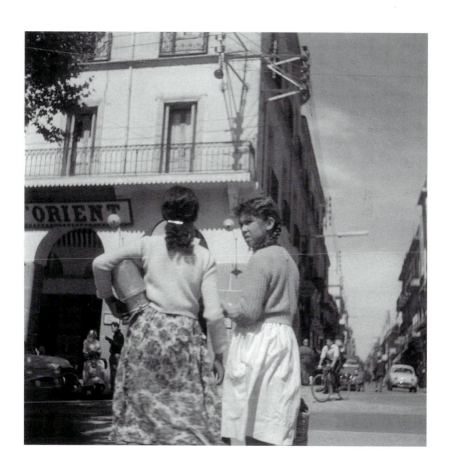

of landless farmers or of a population eking out an existence as sharecroppers or farm workers in the United States in the 1930s. Above all James Agee and Walker Evans's joint text/image work, their lucid, committed, and dignified description of the miserable life of three leasehold farmer families in *Let Us Now Praise Famous Men*[4] (a description that equally critically discusses their own activity of describing) marked a turning point in the reflexivity of documentary/artistically committed work and could offer a point of reference in the analysis of these photographs. For in a similar manner, Bourdieu succeeds in creating a basis of trust and a distance of respect that allow him to engage in a photographic practice that documents his commitment, his veracity, and his affection (and, in view of this perhaps already bold comparison, we must not forget that this work was done in a state of war, where it is only coincidences that often decide between life and death).

It was very illuminating for us to recognize the precision with which Bourdieu approached the subject of his study as a photographer in the sense of complete photographic coverage of a given context. He veritably circled around the objects of his research with his camera, always selecting different perspectives and approaches to his "object." Or he recorded everything that happened in front of his camera as a passive observer. For example, there is a sequence of almost twenty pictures of a crossroads in Blida in which passersby walk past Bourdieu's camera from the same angle of view. A similar series features pictures of a newspaper kiosk in the square not far from this street corner in Blida, where, like a running film, changing groups of children and adults crowd around the magazine displays. Because Bourdieu worked with a rangefinder camera, the plane of view in his photographs is always very low; the possibility of operating the camera at chest height allowed him to take photos even in difficult situations and almost unnoticed without having to raise the camera up to eye level.

Our collaboration with Pierre Bourdieu began in 2000, under very different circumstances than would be decisive with regard to the creation of this book. The reason for this was that 2000 was a political watershed for us (in

Austria): With the Austrian Freedom Party now in the coalition government, it seemed that a xenophobic and anti-intellectual consensus had become hegemonic in Austria, justifying fears that a reduction of complexity could become the leitmotif of a new political line in Austria. In this political setting and at this time, Bourdieu supported the debate conducted in our magazine, publishing his first text with us, "Against a Politics of Depoliticization," an important statement in connection with the European social movement against a politics of globalization and neoliberalism that he demanded.[5]

Finally, it was Franz Schultheis, acting as mediator between Bourdieu and the curatorial team of *Camera Austria,* who presented to us Bourdieu's largely unpublished photographic archive that he had created during his field-specific ethnological studies in Algeria in the 1950s. Bourdieu was initially skeptical about an exhibition and publication project, as he did not wish to see the artistic, aesthetic effect of his photos overrated. It was also important for us to consider whether a project so emphatically entrenched in the art context as *Camera Austria* could be a suitable institution to process Bourdieu's ethnographically defined photographic material. But particularly against the backdrop of Bourdieu's exploration of the photography medium and his essays on the definition and analysis of the field of art and its effects in society, it appeared extremely interesting to us to subject Bourdieu's photographic documents themselves to an analysis. But the opportunity of scrutinizing this significant body of photographs also implied returning to our core sphere, the processing of photographic material and its societal, political, and cultural importance, and discussing these photographs and Bourdieu's position, also in the context of art, by presenting this exhibition at *Camera Austria* exhibition space at Kunsthaus Graz in the autumn of 2003.[6]

© Christine Frisinghelli/*Camera Austria*

ACKNOWLEDGMENTS

Our thanks are due to Pierre Bourdieu for his trust in this joint project and his cooperation right up to shortly before his death. We would like to thank Jérôme Bourdieu for his support and constructive discussions, particularly during the last stage of the project. Franz Schultheis created the actual framework that allowed us to embed Bourdieu's photographic documentations in a scientific, biographical, and historical context. Thanks to Salah Bouhmedja for the patient help in sifting through the archive and commenting on and identifying the photographs. And finally, thanks to the organizers of the "Graz 2003—Cultural Capital of Europe" program for the core funding of this complex project.

Translated from the German by Richard Watts

WORKS BY PIERRE BOURDIEU ON ALGERIA

Sociologie de l'Algérie (coll. *Que sais-je*), 802. Paris: PUF, 1958; new and revised edition, 1961; 8th edition, November 2001.

"La logique interne de la civilisation algérienne traditionnelle," *Le Sous-Développement en Algérie*. Algiers: Secrétariat Social, 1959, pp. 40–51.

"Le choc des civilisations," *Le Sous-Développement en Algérie*. Algiers: Secrétariat Social, 1959, pp. 52–64.

"Guerre et mutation sociale en Algérie," *Études méditerranéennes*, 7, Spring 1960, pp. 25–37.

"Révolution dans la révolution," *Esprit*, 1, January 1961, pp. 27–40; also P. Bourdieu, *Interventions (1961–2001). Science sociale et action politique*, T. Discepolo, F. Poupeau (Eds.). Marseille: Agone, 2002, pp. 21–28.

"De la guerre révolutionnaire à la révolution," *L'Algérie de demain*, F. Perroux (Ed.). Paris: PUF, 1962, pp. 5–13; also P. Bourdieu, *Interventions (1961–2001). Science sociale et action politique*, T. Discepolo, F. Poupeau (Eds.). Marseille: Agone, 2002, pp. 29–36.

"La hantise du chômage chez l'ouvrier algérien. Prolétariat et système colonial," *Sociologie du travail*, 4, 1962, pp. 313–331.

"Les sous-prolétaires algériens," *Les Temps modernes*, 199, December 1962, pp. 1030–1051; also Agone, "Revenir aux luttes," 26–27, 2nd trimester 2002, pp. 203–223.

Travail et travailleurs en Algérie. Paris/The Hague: Édition Mouton, 1963 (2nd edition, with A. Darbel, J. P. Rivet, C. Seibel).

"La société traditionnelle. Attitude à l'égard du temps et conduite économique," *Sociologie du travail*, 1, January–March 1963, pp. 24–44.

Le Déracinement: la crise de l'agriculture traditionnelle en Algérie (with Abdelmalek Sayad). Paris: Éditions de Minuit, 1964; new edition, 1996.

"The Attitude of the Algerian Peasant Toward Time" (translated by G. E. Williams), *Mediterranean Countrymen*, J. Pitt-Rivers (Ed.). Paris/The Hague: Édition Mouton, 1964, pp. 55–72.

"Paysans déracinés, bouleversements morphologiques et changements culturels en Algérie," *Études rurales*, 12, January–March 1964, pp. 56–94 (with Abdelmalek Sayad).

"The Sentiment of Honour in Kabyle Society" (translated by P. Sherrard), *Honour and Shame. The Values of Mediterranean Society*, J. G. Peristiany (Ed.). London: Weidenfeld and Nicholson, 1965, pp. 191–241.

"La maison kabyle ou le monde renversé," *Échanges et communications. Mélanges offerts à Claude Lévi-Strauss à l'occasion de son 60ᵉ anniversaire*, J. Pouillon and P. Maranda (Eds.). Paris/The Hague: Édition Mouton, 1970, pp. 739–758; also "La maison ou le monde renversé," in P. Bourdieu, *Esquisse d'une théorie de la pratique*. Paris: Édition du Seuil, 2000, pp. 61–82. (1st edition, Geneva: Droz, 1972, pp. 45–59, 64–69).

"Formes et degrés de la conscience du chômage dans l'Algérie coloniale," *Manpower and Unemployment Research in Africa*, vol. 4, 1, April 1971, pp. 36–44.

Esquisse d'une théorie de la pratique, précédé de trois études d'ethnologie kabyle. Geneva: Droz, 1972; paperback (revised and expanded edition). Paris: Édition du Seuil (coll. "Points Essais"), 2000.

"Les conditions sociales de la production sociologique: sociologie coloniale et décolonisation de la sociologie," contribution to the colloquium "Ethnologie et politique au Maghreb" (Paris, June 1975); *Le mal de voir*. Paris: Union Générale d'Éditions (UGE) (coll. 10/18), Cahiers Jussieu 2, 1976, pp. 416–427; also "Pour une sociologie des sociologues," P. Bourdieu, *Questions de sociologie*. Paris: Éditions de Minuit, 1980, pp. 79–85.

Algérie 60. Structures économiques et structures temporelles. Paris: Éditions de Minuit, 1977.

"Dialogue sur la poésie orale," *Actes de la recherche en sciences sociales*, 23, September 1978, pp. 51–66 (with M. Mammeri); also M. Mammeri, *Culture savante. Culture vécue*, "Études, 1938–1989." Algiers: Tala, 1991, pp. 93–123.

Le Sens pratique. Paris: Éditions de Minuit, 1980.

"Du bon usage de l'ethnologie" (with M. Mammeri), *Awal*, Cahiers d'études ber-
bères, 1, 1985, pp. 7–29; also M. Mammeri, *Culture savante. Culture vécue*,
"Études 1938–1989," Algiers: Tala, 1991, pp. 173–187.

"Préface," in T. Yacine Titouh, *L'Izli ou l'amour chanté en kabyle*. Paris: Édition de la
Maison des Sciences de l'Homme, 1988, pp. 11–12.

"Mouloud Mammeri ou la colline retrouvée," *Le Monde*, March 3, 1989; also *Awal*,
November 5, 1989, pp. 1–3.

"L'odyssée de la réappropriation," *Le Pays* (Algeria), 60, June 27–July 3, 1992, p. 6;
also *Awal* ("La dimension maghrébine dans l'oeuvre de Mouloud Mammeri."
Documentation of the colloquium in Algiers, June 1992), 18, 1998, pp. 5–6.

"La réappropriation de la culture reniée: à propos de Mouloud Mammeri," T. Ya-
cine (Ed.), *Amour, phantasmes et sociétés en Afrique du Nord et au Sahara*. Paris:
L'Harmattan–*Awal*, 1992, pp. 17–22.

"L'intelligence qu'on assassine" (interview with E. Sarner), *La Chronique d'Amnesty
International*, 86, January 1994, pp. 24–25.

"Le parti de la paix civile," *Alternatives algériennes*, 2, November 22–December 7,
1995, p. 4 (with M. Virolle).

"Dévoiler et divulguer le refoulé" (Freiburg, October 27, 1995), *Algérie–France–Islam*,
J. Jurt (Ed.). Paris: L'Harmattan, 1997, pp. 21–27; also P. Bourdieu, *Interventions
(1961–2001). Science sociale et action politique*, T. Discepolo, F. Poupeau (Eds.).
Marseille: Agone, 2002, pp. 321–325.

"Hommage à mon ami Abdelmalek Sayad," *Libération*, March 16, 1998, p. 31.

"Préface," A. Sayad, *La double absence. Des illusions de l'émigré aux souffrances de
l'immigré*. Paris: Édition du Seuil, 1999, pp. 9–13.

"The Organic Ethnologist of Algerian Migration" (comment on Sayad), *Ethnogra-
phy*, 1(2), 2000, pp. 173–182 (with L. Wacquant).

"Entre amis" (Institut du Monde Arabe. Paris, May 21, 1997), *Awal*, 21, 2000,
pp. 5–10; also P. Bourdieu, *Interventions (1961–2001). Science sociale et action
politique*, T. Discepolo, F. Poupeau (Eds.). Marseille: Agone, 2002, pp. 37–42.

"Pour Abdelmalek Sayad" (Paris, Institut du Monde Arabe, 1998), *Annuaire de
l'Afrique du Nord*, 37, 1998. Paris: CNRS Éditions, 2000, pp. 9–13.

"Foreword," J. D. Le Sueur, *Uncivil War. Intellectuals and Identity Politics During the Decolonization of Algeria.* Philadelphia: University of Pennsylvania Press, 2001, pp. ix–x.

LIST OF PHOTOGRAPHS

PICTURES FROM ALGERIA

P. 37, Lasseube, Béarn, L 8.

P. 38, Lasseube, Béarn, L 12.

P. 39, Lasseube, Béarn, L 4.

WAR AND SOCIAL TRANSFORMATION IN ALGERIA

P. 41, N 66/556.

P. 45: (top) N 28/6; (bottom) N 35/158.

P. 46: (top) N 47/282; (bottom) N 90/838.

P. 47: (top) N 46/434; (bottom) N 81/690.

P. 49, N 17/464.

P. 50, N 50/248.

P. 54, N 4/6.

P. 55, N 28/7. GPRA = Provisional Government of the Algerian Republic

P. 56, O 80/682.

P. 57, Blida, O 59/500.

P. 61, R 10.

P. 63, Ain Aghbal, Collo, O 76/656.

P. 64, O 76/653.

P. 65, Tixeraine, December 1959, O 65/552.

HABITUS AND HABITAT

P. 67, Cheraia, resettlement center under construction, N 85/766. Photograph
published on the cover of *Le Déracinement*.

P. 69, Cheraia, O 25/753.

P. 70: (top) SAS of Cheraia, N 84/719; (bottom) Cheraia, N 84/715.

P. 71, Cheraia, O 83/771.

P. 72, Ain Aghbal, Collo, N 90/896.

P. 74, the resettlement of Djebabra, Chlef, with routes of resettled peasants, taken from *Le Déracinement*.

P. 75, Djebabra, Chlef, resettlement center: (top) N 9/1; (bottom) N 29/2.

P. 76, Djebabra, Chlef, resettlement center: (top) O 29/6; (bottom) N 29/8.

P. 77, Djebabra, Chlef, O 31/1.

P. 78, Djebabra, Chlef: (top) N 31/6; (bottom) N 31/2.

P. 79, O 3/3.

P. 81, N 15/728.

P. 82, sketch of a Kabyle house plan; written by Pierre Bordieu, collection of Algerian records.

P. 83, Ain Aghbal, Collo, N 88/786.

P. 84, plan of a Kabyle house, published in *Le Sens pratique*.

P. 85, Ain Aghbal, Collo, N 25/724.

P. 86, Ain Aghbal, Collo N 26/2009.

P. 87, N 24/2012.

P. 88, Ain Aghbal, Collo, N 24/2011.

MEN–WOMEN

P. 91, Djebabra, Chlef, O 9/7.

P. 93, Djebabra, Chlef, O 9/4.

P. 94, Djebabra, Chlef, N 9/6.

P. 95, Ain Aghbal, Collo, N 6/7.

P. 96, Ain Aghbal, Collo, from album (photo taken with a Leica), K 1a.

P. 97, Ain Aghbal, Collo, from album (photo taken with a Leica), K 1b.

P. 98, Ain Aghbal, Collo, from album (photos taken with a Leica): (top) K 1c; (bottom) K 1d.

P. 99, Ain Aghbal, Collo, from album (photos taken with a Leica): (top) K 4e; (bottom) K 1f.

P. 100, Ain Aghbal, Collo, from album (photos taken with a Leica): (left) K 2a; (right) K 2c.

P. 101, Ain Aghbal, Collo, from album (photos taken with a Leica): (top) K 2e; (bottom) K 2d.

P. 102, men's work, women's work; written by Pierre Bourdieu, collection of Algerian records.

P. 103, men's work, women's work; written by Pierre Bourdieu, collection of Algerian records.

P. 105, Ain Aghbal, Collo, O 87/780.

P. 106, the fountain in Ain Aghbal, Collo, O 87/783.

P. 107, the fountain in Ain Aghbal, Collo, N 92/809.

P. 108, Ain Aghbal, Collo, O 91/797.

P. 109, Ain Aghbal, Collo: (top) O 88/790; (bottom) O 93/813.

P. 110: (top) the fountain, Matmata, Chlef, N 31/7; (bottom) Cheraia, O 85/762.

P. 111, the fountain, Matmata, Chlef, N 34/144. Pierre Bourdieu is on the left.

P. 113, Lakhdaria (formerly Palestro), O 90/839.

P. 115, Oued Fodda, Chlef, R 3.

AN AGRARIAN SOCIETY IN CRISIS

P. 117, the plowing of fig trees in Kabylia, N 75/644.

P. 120, Ain Aghbal, Collo, N 88/788. Abdelmalek Sayad is in the center, wearing a white shirt.

P. 121, Ain Aghbal, Collo, O 87/781.

P. 122, Ain Aghbal, Collo, N 88/787.

P. 123, the hundred-year-old man of Ain Aghbal, Collo, N 89/793.

P. 124, Ain Aghbal, Collo, O 93/815.

P. 125, Ain Aghbal, Collo, O 93/817.

P. 126, the harvest, resettlement center of Mihoub, R 13.

P. 127, the measuring of grains, Matmata, Chlef, N 89/794.

P. 129, N 33.

P. 130, Cheraia, O 21/754.

P. 131, Cheraia, O 20/757.

P. 133, Cheraia, N 8/6. Photo published on the cover of *Le Sens pratique*.

P. 134, Djebabra, Chlef, N 30/3.

P. 135, Djebabra, Chlef, N 30/4.

P. 138, the sulfating of vines, Mitidja plain, N 48/262. Photo published on the cover of *Travail et travailleurs en Algérie*.

P. 140, N 19/755.

P. 141, Cheraia, R 17.

P. 142, Oued Foundouk, N 3/4.

P. 143, N 19/738.

P. 144, Djebabra, Chlef, O 3/2.

P. 145, O 14/2.

P. 146, R 16.

P. 147, N 5/3.

THE ECONOMICS OF POVERTY

P. 149, a traveling merchant with his son, Orléansville, Chlef, R 14.

P. 151, O 80/684.

P. 152, El Biar, December 1959, O 64/539.

P. 153, O 79/675.

P. 154, R 8.

P. 156, Rouiba, June 1959, O 26/466.

P. 158, a second-hand market, Bab el-Oued, April 1959, R 12.

P. 160, N 55/207.

P. 161, N 68/576.

P. 162, N 4/1.

P. 164, a beggar, Bab el-Oued, N 39/188.

P. 165, Mostaganem, Chlef, O 23/276.

P. 166, O 5/8.

P. 167, in Algiers, O 32/300.

P. 168, Blida, R 9.

P. 170, El Biar, December 1959, O 65/549.

IN ALGIERS AND BLIDA: IMAGE SEQUENCE

P. 173, Avenue de la Marne, Algiers, April 1959, O 36/168.

P. 174, Bresson Square, Algiers, April 1959, O 36/167.

P. 175, Diar el-Mahsoul, Algiers, April 1959, O 38/184.

P. 176, R 11.

P. 177, Diar el-Mahsoul, Algiers, O 38/180.

P. 178, Diar el-Mahsoul, Algiers, April 22, 1959, O 37/171.

P. 179, Blida, April 1960, O 69/578.

P. 180, R 26.

P. 181, Blida, April 1960, O 69/583.

P. 182, Blida, March 1959, O 33/142.

P. 183, O 50/250.

P. 184, Blida, April 1960, O 69/585.

P. 185, Bab el-Oued, O 37/175.

P. 186, Bab el-Oued, April 1959, O 38/177.

P. 187, Bab el-Oued, April 1959, O 55/202.

P. 188, Bab el-Oued, April 1959, O 55/203.

P. 189, Algiers, May 1959, O 58/491.

P. 190, Bab el-Oued, June 1959, O 40/196.

P. 191, fair in Algiers, April 1959, O 53/224.

P. 192, fair in Algiers, April 1959, O 54/212.

P. 193, fair in Algiers, April 1959, O 54/217.

P. 194, fair in Algiers, April 1959, O 53/222.

COMMENTS ON THE PHOTOGRAPHIC DOCUMENTATIONS OF PIERRE BOURDIEU

NOTES

FOREWORD

1. Bourdieu tells some of the story in Sketch for a Self-analysis (London: Polity Press, 2004).
2. Interview with Pierre Bourdieu, in the present book.
3. See Christian Kravagna, "Bourdieu's Photography of Coevalness," *Transversal*, 12, 2007: http://eipcp.net/transversal/0308/kravagna/en and Les Back, "Portrayal and Betrayal: Bourdieu, Photography, and Sociological Life," *The Sociological Review*, 57, no. 3, 2009, pp. 471–489.
4. *The Logic of Practice* (Palo Alto, CA: Stanford University Press, 1990; orig. 1980), p. 3.
5. But see Fanny Colanna on how easily documenting domination could itself become one-sided, underestimating the resources the dominated have for reinterpretation, resistance, and open struggle; "The Phantom of Dispossession," *Bourdieu in Algeria*, Jane E. Goodman and Paul E. Silverstein (Eds.) (Lincoln: University of Nebraska Press, 2009).
6. See Tassadit Yacine, "Pierre Bourdieu in Algeria at War: Notes on the Birth of an Engaged Ethnosociology," *Ethnography*, 5, no. 4, 2004, pp. 487–510.
7. See Azzedine Haddour's examination of Bourdieu's work in relation to some of the most important of these others, especially Germain Tillion, "Bread and Wine: Bourdieu's Photography of Colonial Algeria," *The Sociological Review*, 57, no. 3, 2009, pp. 385–405.
8. The notion of a "miraculé" is basically that of the exception that proves the rule, the brilliant student from the countryside or disadvantaged ethnic group who succeeds despite the odds in the metropolitan educational system (and therefore who may be claimed as a demonstration that the system really was meritocratic and not fundamentally biased).

9. Some of this work was reported in "Les relations entre les sexes dans la société paysanne," *Les Temps modernes,* 195, August 1962, pp. 307–331. But in his typical fashion Bourdieu worked it over repeatedly, notably in "Les stratégies matrimoniales dans le système de reproduction," *Annales,* 4–5, July–October 1972; in *The Logic of Practice* (Palo Alto, CA: Stanford University Press, 1990); and in *The Bachelors' Ball* (Chicago: University of Chicago Press, 2007).

10. Asking "Why not?" would take us too far afield, but beyond whatever accidents of intellectual history may have intervened it would seem that there was a much greater appetite for symbolically focused studies of the traditional societies, the exotic "other" of anthropology, than for messier accounts of urban poverty, exploitation, and domination. But at the same time, Bourdieu did less than he might have to integrate these two sides of his work, the account of how a cultural order worked and of the experience of deculturation.

11. As Paul A. Silverstein stresses, the reality of rupture doesn't mean there was no continuity: "Of Rooting and Uprooting: Kabyle Habitus, Domesticity, and Structural Nostalgia," *Ethnography,* 5, no. 4, 2004, pp. 553–578.

12. Bourdieu, *Distinction* (Cambridge, MA: Harvard University Press, 1984); Bourdieu and collaborators, *The Weight of the World: Social Suffering in Contemporary Society* (Palo Alto, CA: Stanford University Press, 2000). The English title loses the connection to Proudhon's *Philosophie de la misère* and Marx's response, *Misère de la philosophie.*

13. Many Kabyle and other Berbers were nonetheless active. Bourdieu's emphasis on limits imposed by Arab dominance of the independence movement was a major difference from the otherwise largely similar views of Franz Fanon. See Bourdieu, "Révolution dans la révolution," *Esprit,* 1, January 1961, pp. 27–40.

14. Bourdieu would later stress the potential for revision more: "Habitus changes constantly in response to new experiences. Dispositions are subject to a kind of permanent revision, but one which is never radical because it works on the basis of premises established in the previous state," *Pascalian Meditations* (Palo Alto, CA: Stanford University Press, 2000), p. 161. But what Bourdieu saw in Algeria was "a pathological acceleration of social change," as he and Sayad put it in *Le Déracinement*—precisely change so fast that the constant adjustment of the habitus could not keep up. See also discussion in Wacquant, "Following Bourdieu into the Field," *Ethnography,* 5, no. 4, 2004, pp. 387–414.

15. Pierre Bourdieu, "Unifying to Better Dominate," in *Firing Back* (New York: New Press, 2002).

16. For a sample of critical articles see *Bourdieu in Algeria*, Goodman and Silverstein (Eds.).

17. Something of this is brought out in Bourdieu's remarkable dialogues with Mouloud Mammeri in which that legendary Kabyle intellectual makes clear the collective work and both creative and critical discourse that go into making tradition. See "Dialogue on Oral Poetry," *Ethnography*, 5, no. 4, 2004 (orig. 1978), pp. 511–551.

PIERRE BOURDIEU AND ALGERIA

1. From the conversation between Pierre Bourdieu and Franz Schultheis, Collège de France, June 26, 2001.

2. Pierre Bourdieu, *Die zwei Gesichter der Arbeit*. Constance: UVK, 2000.

3. It is very important for us to thank those people who contributed significantly to the realization of this project at various stages. Thanks to the following for their expertise and practical support: Fadila Boughanemi, Salah Bouhmedja, Daniela Böhmler, Andrea Buss-Notter, Pierre Carles, Christian Ghasarian, Marc-Olivier Gonseth, Jacques Hainard, Melk Imboden, Peter Scheiffele, Eva Schrey, Anna Schlosser, Kristina Schulz, Thierry Wendling, Tassadit Yacine, and Nicola Yazgi. My thanks are due also to Remi Lenoir for his critical reading of this text and his intelligent suggestions, and to Christine Frisinghelli for the always inspiring transdisciplinary collaboration.

PICTURES FROM ALGERIA

1. Extended version of the interview published in *Camera Austria*, 75, Graz, 2001, entitled "Participatory Objectification: Photographic Testimonies of a Declining World" (with a preface by Franz).

2. *Algérie 60. Structures économiques et structures temporelle*. Paris: Éditions de Minuit, 1977; English: *Algeria 1960*. Cambridge: Cambridge University Press, 1979.

3. *Travail et travailleurs en Algérie* (with A. Darbel et al.). Paris: Éditions de Minuit, 1965.

4. *Un art moyen. Essai sur les usages sociaux de la photographie* (with L. Boltanski et al.). Paris: Éditions de Minuit, 1965; English: *Photograph: A Middle Brow Art*. London: Polity Press, 1990.

WAR AND SOCIAL TRANSFORMATION IN ALGERIA

1. A poll carried out in a library near Algiers has shown that adults read a lot, including books of a high literary standard. The popularity of French papers (*Le Monde,* in particular), which sprang out of a desire for information about politics, has contributed greatly to the development of this appetite for education, the key to which might be seen in what one Algerian child told Robert Daveziès (in *Le Front,* Paris, Minuit): "If Algeria's free and I still can't write, it won't be any use."
2. The contrary is also true. Europeans of Algerian origin have told me how amazed they were, on arriving in France, to see French people working as laborers or street sweepers, and living in slums, "like Arabs."
3. See *La Femme musulmane* (propaganda pamphlet). Algiers: 1958.
4. Practical arrangements are generally worked out between the arriving refugees and the departing inhabitants, for example with regard to the sharing of harvests.

THE ECONOMICS OF POVERTY

1. In Arabic, *el ktaf* means "shoulder" or "influence."
2. A pejorative word meaning "agricultural laborer" or "day laborer."

COMMENTS ON THE PHOTOGRAPHIC DOCUMENTATIONS OF PIERRE BOURDIEU

1. Pierre Bourdieu, *Sozialer Sinn. Kritik der theoretischen Vernunft* (The Logic of Practice). Frankfurt a.M.: Suhrkamp, 1987, p. 8.
2. Pierre Bourdieu/Franz Schultheis, interview, *Camera Austria,* 75, Graz, 2001 (German/English).
3. Pierre Bourdieu, *Ein soziologischer Selbstversuch.* Frankfurt: Suhrkamp, 2002.
4. James Agee/Walker Evans, *Let Us Now Praise Famous Men.* Boston: Houghton Mifflin, 1941.
5. *Camera Austria,* 72, Graz, 2000.
6. The following members of the *Camera Austria* curator team are significantly involved in designing the exhibition and developing the book project: Christine Frisinghelli, Seiichi Furuya, Maren Luebbke-Tidow, Anja Rösch, and Manfred Willmann.